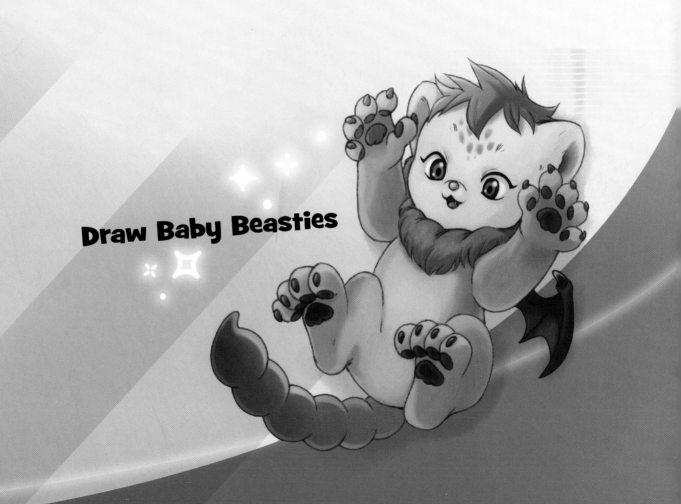

Draw Baby Beasties

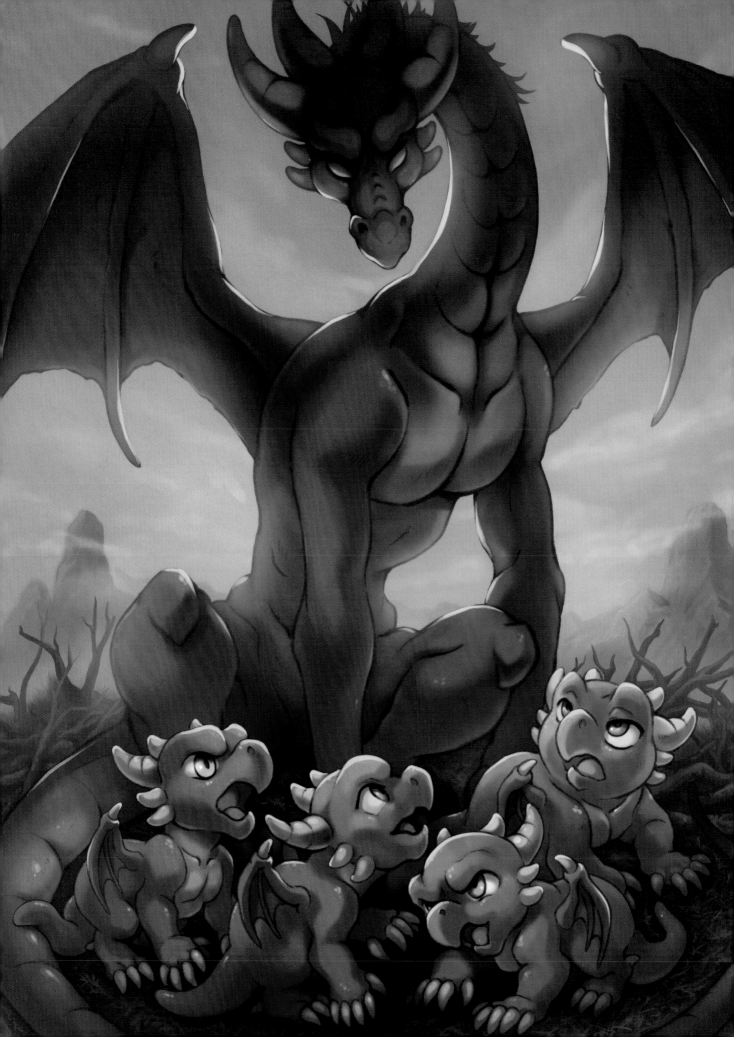

Draw Baby Beasties

Create Little Dragons, Unicorns, Mermaids and More

Lindsay Cibos & Jared Hodges

IMPACT
CINCINNATI, OHIO
www.IMPACTUniverse.com

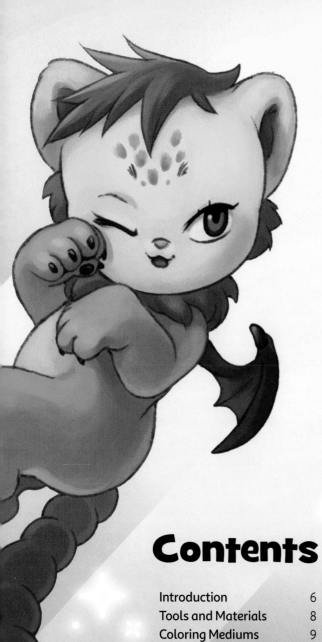

BEASTIE DEMONSTRATIONS

Contents

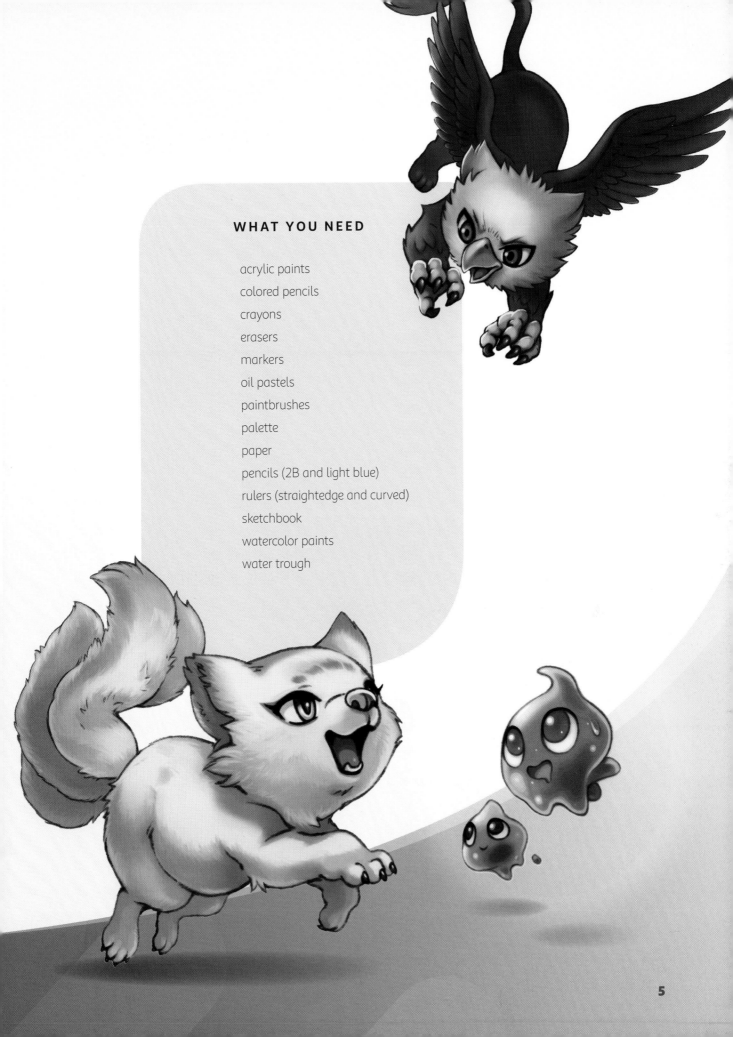

WHAT YOU NEED

acrylic paints

colored pencils

crayons

erasers

markers

oil pastels

paintbrushes

palette

paper

pencils (2B and light blue)

rulers (straightedge and curved)

sketchbook

watercolor paints

water trough

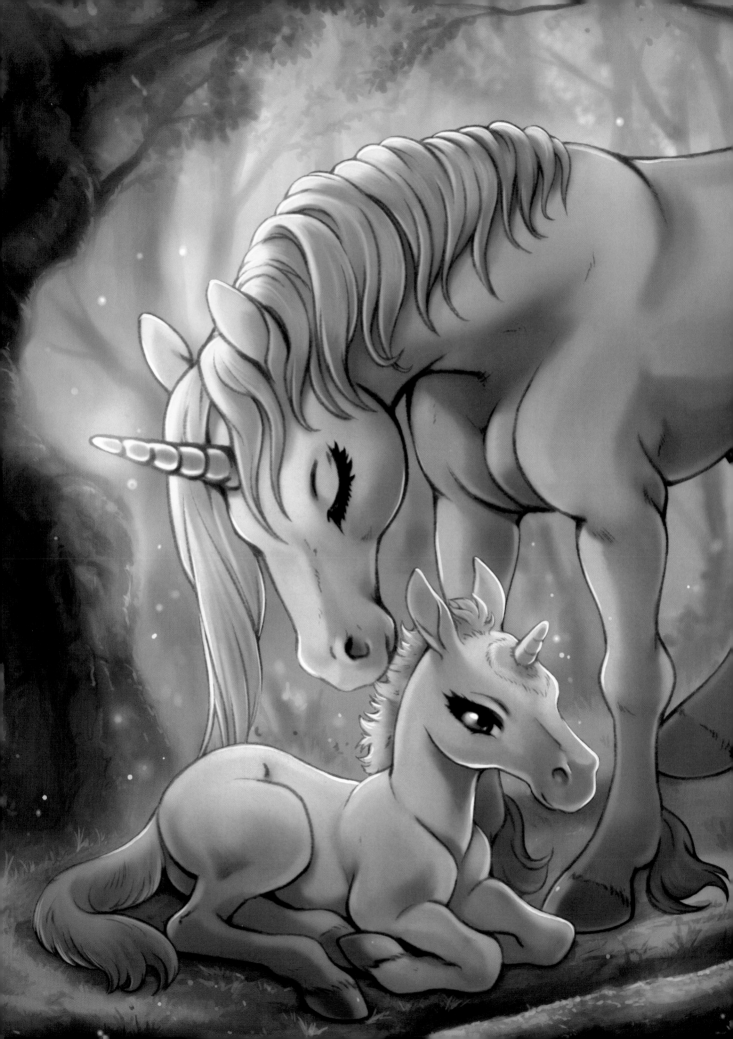

Introduction

There is a realm beyond truth and taxonomy, the material and mundane, where fantastical creatures abound.

Whether scaled, feathered or horned, they captivate and inspire us with their magic and majesty. Legendary beasties appear in every era and reside in every corner and culture throughout our world (and beyond). A mass of myths and stories speak of the mature lives of these extraordinary entities, but little is known of their early years. Questions go unanswered: Do phoenixes have families? Is the unicorn born with its horn? Where do dragons learn the skills for survival? In other words, what are these beasties like as babies? And as important … what do they look like?

Prepare to "ooh" and "ahh" as we encounter the most ferocious and fanciful of beasties at their most adorable. Throughout this book, we'll travel deep within enchanted groves to witness unicorn foals learning to stand, we'll climb cliffs to view baby griffins as they emerge from eggs, and we'll even take a voyage out to sea where massive newborn krakens toss boats like toys in a bathtub.

Along the way, I'll show you how to build your own baby beasties, step-by-step, from basic shapes to finished colored figures. As you rack up experience points, you'll be able to depict them with lively poses and solid anatomy, as well as a range of expressions, making it easy to tell whether your whelps are feeling sleepy, hungry, grumpy or ready to attack.

So roll the dice and take the initiative. Equip a sketchbook and some drawing supplies, and set out on a journey into the world of fantasy and imagination … the realm of baby beasties!

Tools and Materials

You won't need much to start your quest of drawing baby fantasy creatures. The most important things are a pencil, eraser, paper and your imagination. No fancy or expensive art supplies are required. There are no wrong or right tools for expressing creativity. I recommend starting with the supplies you have around the house.

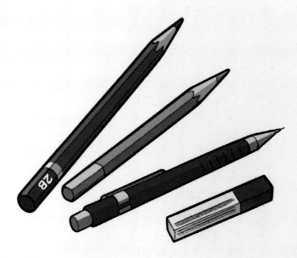

Pencils

A light blue pencil is useful for an exploratory first draft. I use a 2B pencil for sketching. The "B" refers to the degree of blackness of the graphite—the scale ranges from 9H (hardest and lightest) to H, and then B to 9B (darkest and softest). Most basic pencils use a balanced, middle-of-the-scale, HB graded graphite. For precise lines and final drafts, I use a mechanical pencil with 0.5mm HB lead.

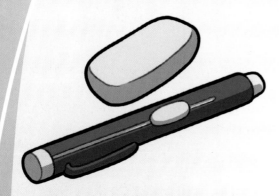

Erasers

I use a Staedtler Mars refillable eraser stick for general erasing, a Magic Rub vinyl eraser for large mistakes, and a brush to sweep away the eraser crumbs.

Rulers

A straightedge or a ruler is a must for drawing perfectly straight lines. A French curve can assist with precise drawing of tricky curved lines. Circle and ellipse guides are great for circular-shaped objects.

Paper

I recommend a sketchbook for jotting ideas on the go, quality drawing paper for your finished drawings, and general paper for sketching. Newsprint, copier or printer paper is also fine in a pinch.

Coloring Mediums

Color mediums come in three forms: wet, dry and digital. Experiment with different coloring mediums to discover which you enjoy. Each has its own characteristics and messiness factors, plus you may find that one is better than another for achieving certain effects. The art in this book was drawn and colored digitally in CLIP STUDIO PAINT and Photoshop CS6.

Dry

Colored pencils, fast-drying markers and oil pastels all have their own appealing characteristics. Don't overlook the humble crayons—they have a childlike charm perfect for baby beasties.

Wet

Acrylic paints and watercolors are some of your options. Get a large brush for covering large areas with color, small brushes for detail work, paper appropriate for the media, a water trough, and a palette for holding and mixing paint.

Painting With Pixels

If you're interested in going the digital route with drawing and/or coloring your creatures, you'll need a PC or laptop, a graphics tablet, possibly a scanner, and a graphics application like CLIP STUDIO PAINT, PaintTool SAI or Adobe Photoshop.

REFERENCE MATERIALS

Usually, when you're drawing an animal, you can use reference materials like photos and videos to assist with accuracy. While we don't have that luxury when working with fantastical beasts (unless you're a wizard who can summon one into existence), there's plenty of inspiration to derive from their real life equivalents (horses for unicorns, reptiles and birds for dragons, etc.). Studying the anatomy, proportions and details of actual creatures is helpful for adding believability to your fantasy creatures.

Drawing With Shapes

Shapes are the building blocks of drawing. If you can draw spheres, cylinders and cubes, then you're already halfway to drawing all kinds of baby beasties. Start by freehand sketching simple lines, squares and circles. There is no need to grab a ruler or circle guide; this exercise isn't about perfection. Focus on pulling your pencil across the paper to make smooth, continuous lines. Once you're comfortable with two-dimensional shapes, you can graduate to drawing three-dimensional objects. Let's take a look at the basic shapes that go into drawing anything … with a little help from some slime pals!

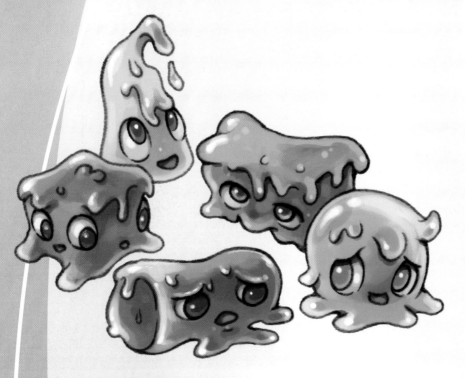

Building Blobs

Using the basic forms of cubes, cones, cylinders and spheres, you can draw anything from squishy slimes to massive fire-breathing dragons. Practice drawing them until they become second nature. Try drawing them at various sizes and every angle. Connect two or more shapes together to create new shapes.

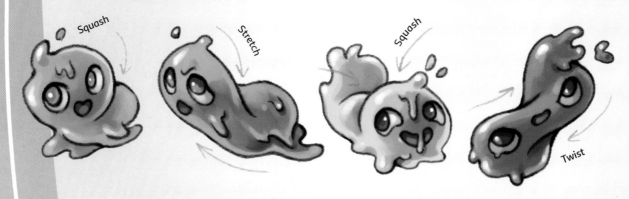

Squash and Stretch

Don't be afraid to compress and stretch the body to emphasize an action. Show your creature craning its neck, twisting its torso and scrunching its tummy. Squash and stretch is a basic principle for conveying life in drawings. When one part of the body stretches, the opposite side compresses, and vice versa.

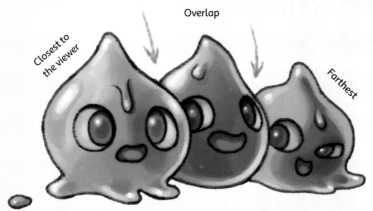

Overlap

Overlap is an important tool for creating a sense of space and three-dimensionality. The concept is simple: when you draw one object overlapping another, it tells us which object is closer to the viewer. In this example, you can tell the green slime is closest because its body partially covers the purple slime.

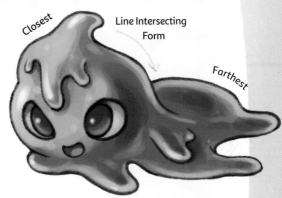

Line Intersecting Form

You can also accomplish overlap using lines intersecting to forms—note how a line helps "pop" this blue slime's head from the rest of its gooey body.

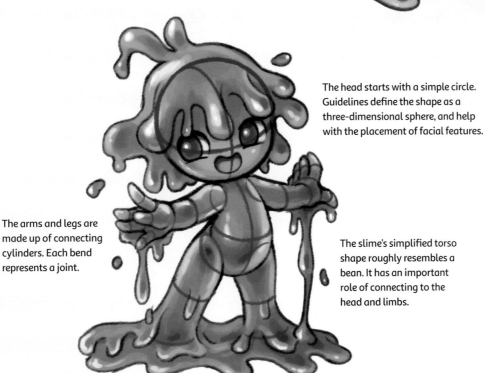

The head starts with a simple circle. Guidelines define the shape as a three-dimensional sphere, and help with the placement of facial features.

The arms and legs are made up of connecting cylinders. Each bend represents a joint.

The slime's simplified torso shape roughly resembles a bean. It has an important role of connecting to the head and limbs.

Sticky Structure

Spheres and cylinders form the basis of this slime kid. It might be tempting to skip directly to drawing the contour lines (the outermost edge), but that can lead to a flat, lifeless drawing. To give your characters a sense of volume, you'll need to start from within by constructing the figure from shapes.

The Drawing Process

Sketching is a process of figuring out how to capture and communicate an image. Don't expect the first lines you draw to capture everything perfectly. Sketching often starts with rough and loose lines that help you visualize a character's design, pose or the composition of the overall image. Going from this rough idea to the final drawing might take several passes of sketching and erasing. Keep going. With each sketch, your ideas becomes clearer, and details more precise, until you've put together a beastie anyone can understand and admire.

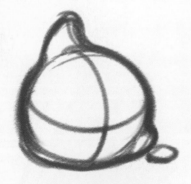

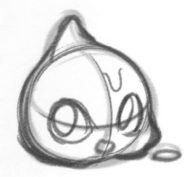

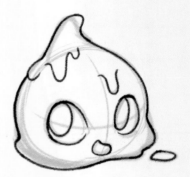

1 Under Drawing
Explore ideas and feel out the character's form. Keep the lines loose and lively.

2 Sketch Lightly
Work over your rough sketch with light pencil lines. Add details and make tweaks. Don't press too hard.

3 Refine Your Drawing
Once you're satisfied, tighten and darken your pencil lines. Then erase any stray or unwanted lines. Almost there!

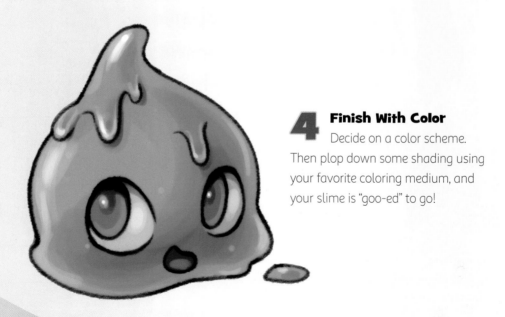

4 Finish With Color
Decide on a color scheme. Then plop down some shading using your favorite coloring medium, and your slime is "goo-ed" to go!

Slime Kid

Slimes are amorphous creatures, often appearing as a puddle of gelatinous ooze. Although they lack a distinct shape, certain varieties of slimes can mold themselves into other forms. This adorable slime kid, curious about humans, has sculpted itself into the form of a young child. Let's take a look at the shapes used to create the slime's new body.

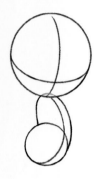

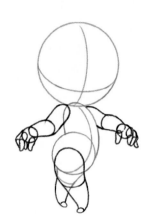

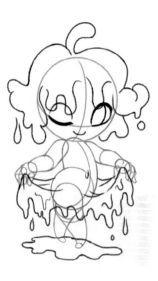

1 Head and Body

Sketch a large circle for the head, with vertical and horizontal guidelines. Then sketch a beanlike shape for the torso, using a small circle for the pelvis area. To specify the bean's front and center, sketch a vertical line curving down the middle of the shape.

2 Arms and Legs

Now that we've established the direction of the head and body, let's add the limbs. To create the arms and legs, sketch interconnecting cylinder shapes, and divide them at the joints, including the knees and elbows. Build up the hands and feet with small circles, and use little sausage-tube shapes for the fingers.

3 Slime

Use curving forms to depict the gooey gobs of "hair" dripping from the slime's head. Use the same technique for the "dress" and slime puddle. To keep the figure soft and gelatinous, avoid using any sharp, jagged or zigzagging lines.

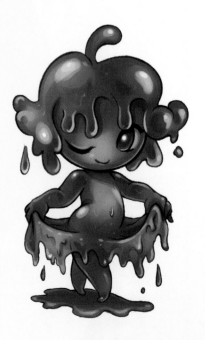

4 Color

Add shading to ooze out the perfect form. Glob some big highlights along the surface, and some darker tones deep within, to make the slime's body seem squishy and semi-opaque. Blobs of body mass drip, puddle, mingle and reform, but through it all, the slime keeps its shape. With a wink and a curtsy this slime is off to play with the human kids.

SLIME KID STATS	
SPEED:	1
STRENGTH:	1
MAGIC:	1
CUNNING:	1
SPECIAL ABILITY:	MIMICRY

Baby Griffin

With a combination of bird and beast traits, the griffin (sometimes spelled griffon or gryphon) has a reputation as a stealthy ambush predator on land or by wing. Resembling a sharp-eyed eagle with a beak, talons and wings, but with a lion's stature and powerful pounce-prone hindquarters, griffins are considered the king of beasts. Admired for their ferocity, resilience and grace, they're popular figures in heraldic imagery. Likewise, their peculiar interest in gold has cast them as guardians of precious treasures.

Within gold-lined nests, baby griffins emerge from their eggs covered in a protective layer of soft fuzz. By the second week, the fuzz is replaced by plumage covering the head, chest and wings. Even as hatchlings, griffins are feisty, fighting their siblings over every scrap of meat. By the twelfth week, they are ready to take their first flight, though they won't be skilled hunters for at least another year.

Plan the Design

Do some exploratory sketches of your griffin. Study lion cubs as the basis for the body and eaglets for the head, forearms and wings. Focus on conveying the animal's personality through the pose and design. We want our little griffin to be playful but fierce, with talons at the ready.

GRIFFIN STATS

SPEED:	4
STRENGTH:	4
MAGIC:	1
CUNNING:	2
SPECIAL ABILITY:	**FLIGHT**

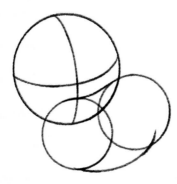

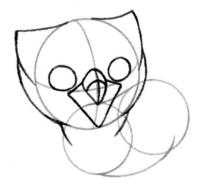

2 Draw the Body

Begin constructing the form. Start with a circle for the head. Add a pair of guidelines to indicate a front-facing direction. Next draw a bean shape for the body comprised of two circles. Draw the lower connecting line intersecting the far circle to make the griffin's chubby lion cub belly.

3 Build Up the Head

Connect the head to the body with a pair of inward sloping lines for the neck. Then sketch the eyes along the horizontal guideline. Fluff out the shape of the head, and add a pair of triangular earlike tufts along the top. Finally, draw the open mouth as a diamond shape, with the upper beak overlapping the bottom.

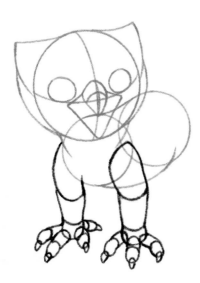

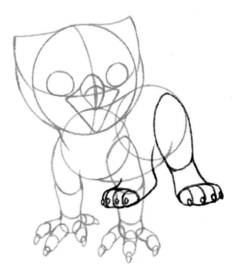

4 Sketch the Front Legs

Sketch the front birdlike legs as long cylinders with separations to indicate bends at the elbow and wrist joints. Don't forget the sharp talons jutting out from each hand—they're useful for catching prey.

5 Sketch the Back Legs

Draw the lionlike hind legs. Don't forget the far leg—it's partially hiding behind the body, but some of the heel and toes are still visible. Indicate a bend between the ankle and leg with a separation line. Divide the front of the foot into four equal sections to create the feline toes. Then add claws.

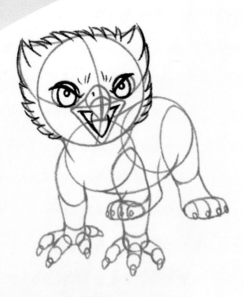

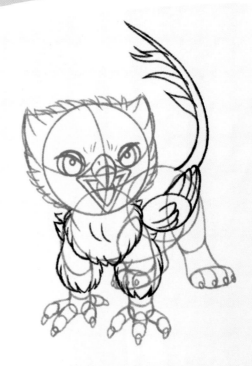

6 **Draw the Facial Features**
Draw the eyes, glaring beneath lowered lids. Add nostrils, a triangle-shaped inner mouth, and a pointy bird tongue to finish the beak. Use jagged lines to define the plumage around the griffin's head and suggest a prickly personality.

7 **Add the Tail, Wings and Fluff**
Add a layer of fluffy plumage to the griffin's chest and front limbs. Draw the folded wing by combining an oval and triangle shape, and then add feathers. Sketch the tail in an alert, upright position, and add spikey fur tufts trailing down the length.

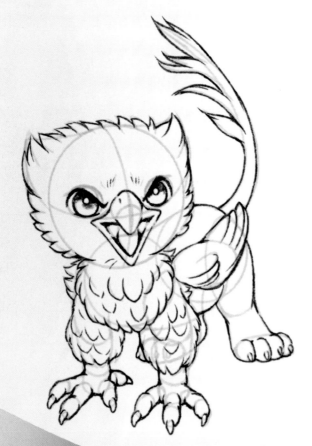

8 **Refine Lines**
Almost done! Add some inner feathers to puff out the plumage. Go over your line art, darkening around creases and shadow areas such as the eyes and under the belly. Erase your guidelines.

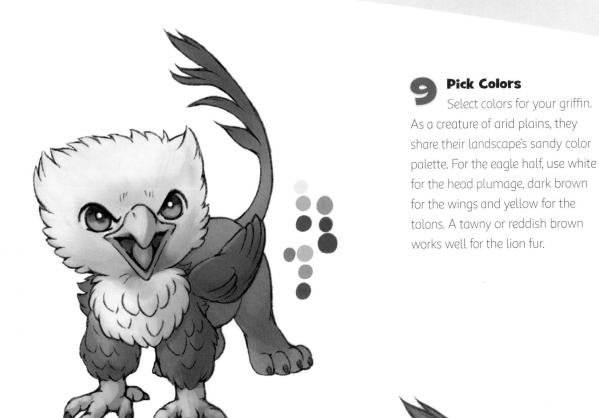

9 Pick Colors

Select colors for your griffin. As a creature of arid plains, they share their landscape's sandy color palette. For the eagle half, use white for the head plumage, dark brown for the wings and yellow for the talons. A tawny or reddish brown works well for the lion fur.

10 Finish With Shading

Apply blue shadow tones to the head plumage using dashed strokes to give the feathers texture and a sense of direction. Smooth the transition from feathers to fur by painting ever-smaller dart-shaped feathers along the griffin's back and midsection. Extrude the knee on the hind leg with heavier shadows. Gradually redden the tail fur as it flows to the tip. Use strong highlights on the beak, talons and claws for a sharp, glossy look.

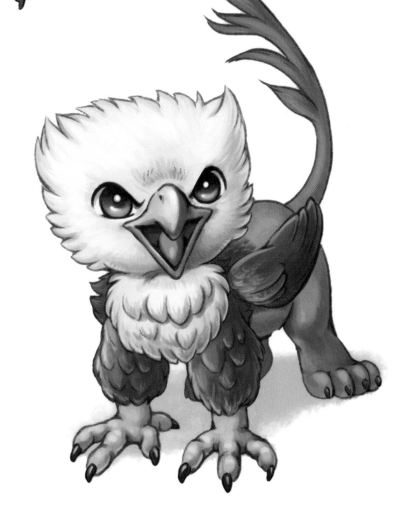

Baby Basilisk

Watch out! Lock eyes with a basilisk and you'll be turned to stone! Half-chicken, half-serpent and all parts terror, adults of this unsociable species flaunt a blood-red comb upon their head, colorful warning plumage, and a scaly, whiplike tail. Despite its reputation as the king of serpents, most basilisks measure a mere 8 to 12 inches (20cm to 30cm) long.

(Their name comes from the Greek word for "little king.") That's smaller than your average chicken, but much deadlier!

A basilisk is formed when a chicken egg is incubated by a toad. The fluffy yellow reptilian chick emerges from the egg, independent and ready to hunt, assisted by venomous talons and a lethal gaze.

Plan the Design

Sketch designs for your baby basilisk. For reference, look at images of baby chickens and reptiles such as snakes and lizards. Action poses with kicking legs can be exciting, but also explore subdued stances that emphasize the basilisk's deadly gaze. Remember, although it has only recently hatched, no one should mistake this creature as helpless—an expression of malevolence says it all.

BASILISK STATS

SPEED:	**3**
STRENGTH:	**2**
MAGIC:	**3**
CUNNING:	**1**
SPECIAL ABILITY:	**PETRIFY**

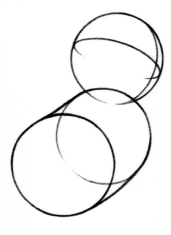

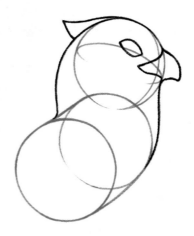

2 Draw the Body

Sketch a circle for the head. Draw the facial guidelines to indicate a head tilt with a side gaze. Then draw the body using two larger circles—one for the chest and one for the hind end, connected into a bean shape. The basilisk's back is turned toward us, so the body should overlap the head.

3 Build Up the Head

Sketch the thickly plumed face and neck by expanding outward from the head ball with curving lines that pull into the body. Add attitude with an angular crest jutting from the head. Draw a diamond-shaped eye along the horizontal guideline. Then sketch a hooked triangular beak from the center of the crosshairs.

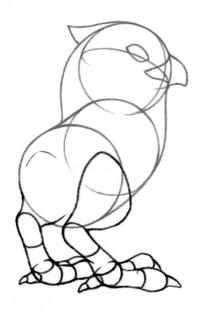

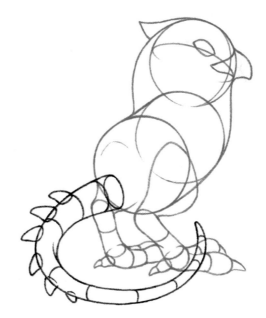

4 Sketch the Legs

A basilisk's legs are like a chicken's. Anchor the meaty thighs to the body and sketch the legs as a solid feathery form. Then, from the heel joint, sketch the scaly feet as a long cylinders. Add clawed toes to the end of each foot. Note that while most birds have four toes, basilisks bear only two front-facing toes and one in the rear, giving them very distinguished Y-shaped tracks.

5 Sketch the Tail

Sketch the serpentine tail as a long tube shape, curving toward the front of the creature. Use surface lines to help visualize the curvature and shape. Add some jutting spines running along the back of the tail.

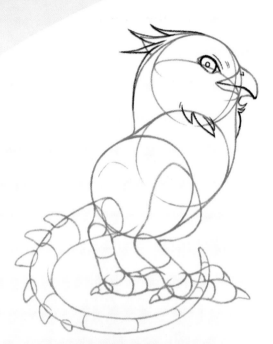

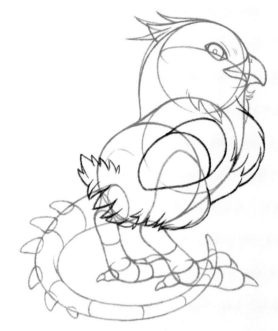

6 Draw the Facial Features

Draw the eye with a small pupil to give the basilisk a petrifying stare. Then sketch the inner beak with a deep frown line. Don't forget the angular nostril. Add some feather details along the crest, cheeks and chin.

7 Add Wings and Fluff

Puff the basilisk's chest and thighs with a saw-toothed flurry of feathers. Sketch some additional feathers encircling the base of the tail. Draw the wing folded neatly against its side.

8 Refine Lines

Tidy up your drawing and erase any guidelines. Go over the feathery areas with fine lines. Add some grooves along the front of the leg to suggest overlapping scales (called scutes).

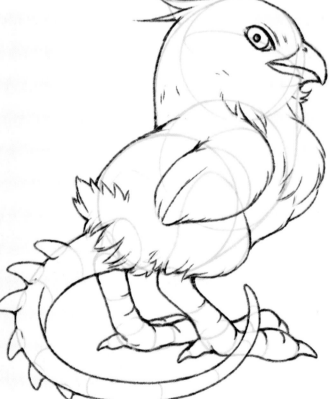

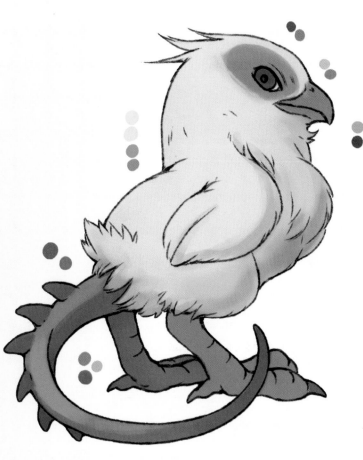

9 Pick Colors

Because this is an immature basilisk, choose plumage colors appropriate for a chick such as yellow or neutral tones like white, brown and black. You can accent it with bright warning colors like red and purple to emphasize the creature's dangerous nature.

10 Finish With Shading

Time to put the finishing touches on this deadly chicken! Use soft shading to define the overall form, and then apply quick strokes to give it a coat of bristling down feathers. Apply some shine along the bony or scaly areas (beak, feet, claws, tail and spines). Give the basilisk an ominous look by painting a white edge around the pupil. Don't forget to paint a scaly pattern on the tail.

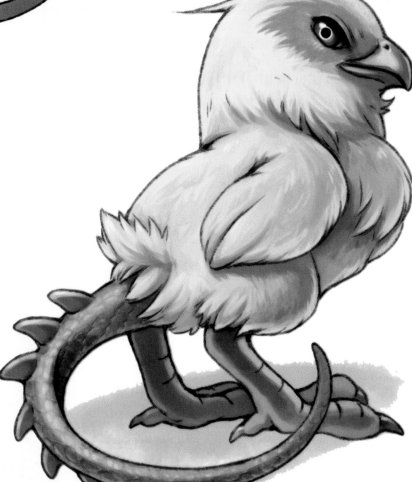

Kitsune Kit

Magical and mischievous, kitsune are multi-tailed foxlike creatures. As they age, they gain additional tails and supernatural powers, ultimately becoming a kyuubi no kitsune (literally "nine-tailed fox" in Japanese). Kitsune can shapeshift into anything from plants to people—how convincing they are depends on their age and ability. From their tails, they can conjure blue magic flames called foxfire.

Baby kitsune, called kits, are born in litters of four to six. Many kitsune begin life with a single tail, but it's not uncommon for a few in the litter to have as many as three or even four tails. The kits spend their time playing with siblings and practicing illusions, close to the safety of the den, relying on their mother and father to bring home tasty morsels.

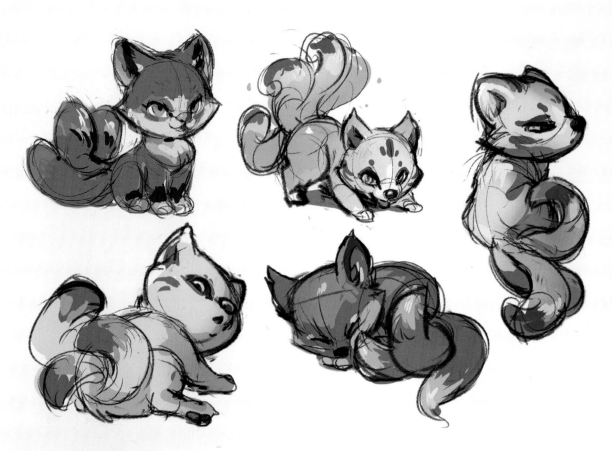

Plan the Design

Sketch some concepts for your kitsune. Refer to imagery of foxes (baby foxes especially) for anatomy and fur reference. There are many varieties of foxes, each with different features you can mix and match to make your kitsune unique. Vibrant colors and patterns can also be applied to the fur for a striking appearance. Sketch the kit's many tails twisting as they bounce and play. You might also want to try a sleepy or clumsy pose to convey youth and inexperience.

KITSUNE STATS

SPEED:	**3**
STRENGTH:	**2**
MAGIC:	**3**
CUNNING:	**4**
SPECIAL ABILITY:	**SHAPESHIFT**

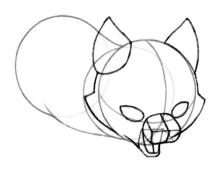

2 Draw the Body

Sketch a circle for the head. Then add vertical and horizontal guidelines to indicate the direction of the kitsune's gaze. Sketch a small circle for the chest, keeping in mind most of it will be obscured by the head. Behind it, draw a larger circle for the hindquarters. Connect them to complete the bean torso shape.

3 Build Up the Head

Sketch a pair of almond-shaped eyes along the horizontal guideline. Add two triangular ears along the top of the head. Build out the boxy muzzle shape from the midpoint of the guidelines. Sketch the lower jaw extending from the base of the snout. Extend the sides of the kitsune's face with angular cheek fur.

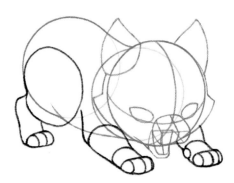

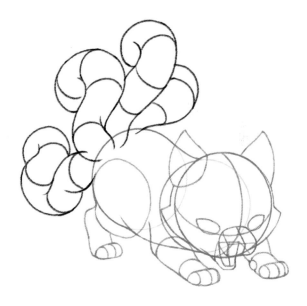

4 Sketch the Legs

Sketch the legs bent in a playful crouch. Indicate the leg joints (elbow, wrist and toes in the front; knee, ankle and toes in the back). Then sketch the toes. Each paw has four toes, plus a thumblike dewclaw on the front ones. Because the inner toes are more set forward, outer toes can often go hidden from certain angles, for example, the far left toe on the back paw. The left hindleg and right foreleg's dewclaw are also obscured.

5 Sketch the Tails

Sketch each of the tails extending from the base of the spine. The more tails the kitsune has, the trickier it is to find space for them. Take your time and plan a path for each one. Wrap surface lines around the tube-shaped tails to keep track of the curvature and form.

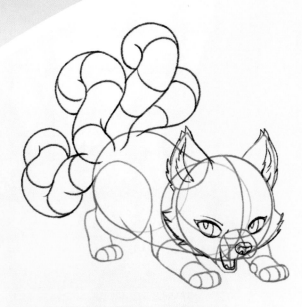

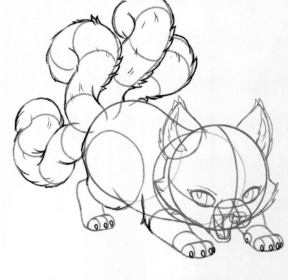

6 Draw the Facial Features

Draw the upper and lower lids and inner eye details. Similar to cat eyes, kitsune eyes can narrow to vertical slits. Fluff out the cheek fur using jagged lines. Do the same for the ears and inner ear fur. Sketch the nose with a distinct top and front side. Finally, draw the inner mouth and pointy canine teeth.

7 Add the Tail, Fluff and Details

Now use jagged lines to pronounce the puffiness of the tails. A few well-placed hatchmarks can create additional texture. Fluff out the knee, elbow and rump areas. Be careful not to overdo it though; too many jagged lines lead to an unkempt appearance. Add claws to the end of each toe.

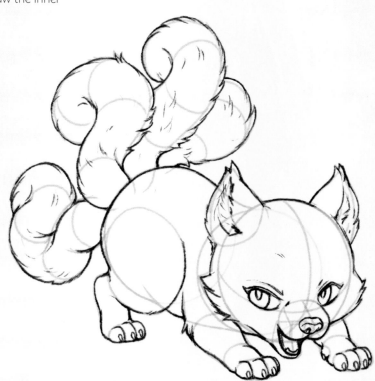

8 Refine Lines

Darken your lines and erase any guidelines. Many of the lines used in the construction of the muzzle can be safely removed, aside from the outer contour and inner mouth details.

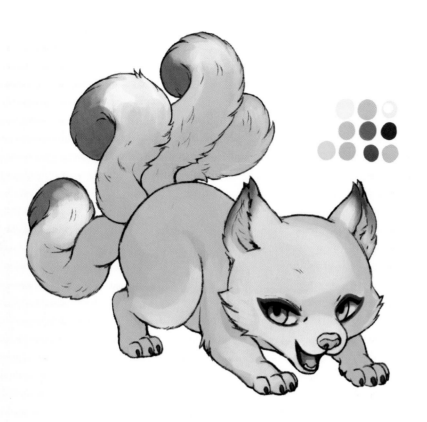

9 Pick Colors

Kitsune fur comes in an array of colors including black, brown, red, gold and silver. This particular kitsune has a golden coat with glowing yellow eyes. Red makes for a striking accent color for patterning on the face, body or tails. Washing in greater degrees of gray-blue can help separate the multiple tails by giving them the feeling of being farther in the background.

10 Finish With Shading

Paint the base fur tone, and add shadows using a darker tone such as purple. Use flecks of a lighter color like warm white to bring out the fur texture and to shine up any wet or glossy areas (eyes, nose and claws). Finally, apply your red accent color, carefully tracing around the eyelids, and blending into the fur. Paint a gray shadow beneath your kit to help ground it.

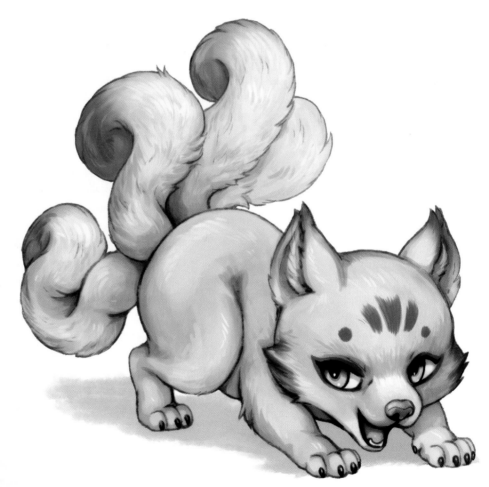

Lil' Jackalope

The elusive jackalope uses its swift reflexes to stay out of sight and its ability to mimic human voices to mislead pursuers. As its name suggests, it has the body of a jackrabbit and the horns of an antelope. (Although some species of jackalope, such as the one pictured here, have antlers like a deer's instead.) They can be found in mountain foothills and grassy desert regions. Should you encounter one, keep your distance—despite its cute and cuddly appearance, a cornered jackalope can be dangerous and will aggressively use its horns to defend itself.

Baby jackalope are born with their eyes open, ready to run. Tiny horn nubs sprout from the top of their heads within the first couple days and grow quickly over the following several weeks.

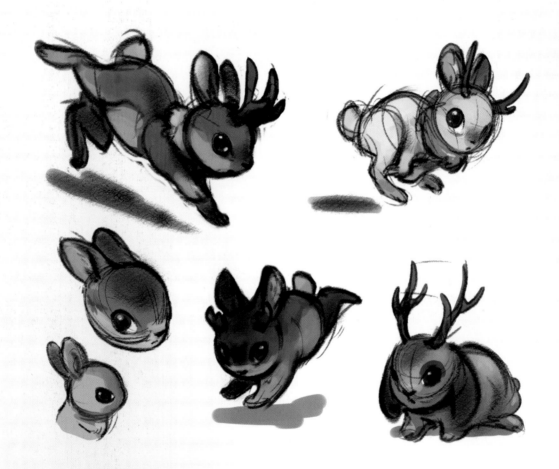

Plan the Design

To highlight the jackalope's skittish nature, try sketching running or jumping poses, and give the critter a cautious expression. Be sure to use circular shapes and curved lines to bring out its cute bunny appeal. Also consider antler length and shape—look at photos of juvenile deer for inspiration.

JACKALOPE STATS	
SPEED:	5
STRENGTH:	1
MAGIC:	1
CUNNING:	2
SPECIAL ABILITY:	**INITIATIVE**

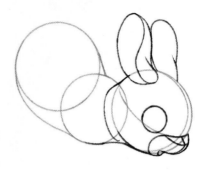

2 Draw the Body

Draw a circle for the head. Sketch the guidelines to indicate facing. This jackalope's head is almost in profile, so place the vertical guideline close to the edge. Next sketch the bean-shaped torso, comprised of a small circle for the chest and a larger circle for its fuzzy rump.

3 Build Up the Head

Sketch the neck to connect the head and chest. Draw a large round eye on the horizontal guideline. From the center point, sketch a small rounded muzzle stretching into an open mouth. Finally, sketch the long bunny ears flapping in the wind. Add a line to indicate the outer edge of the ear.

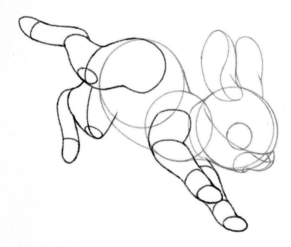

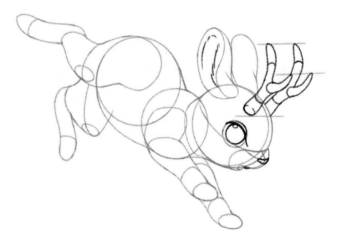

4 Sketch the Legs

Sketch the front limbs stretching out to make contact with the ground. Divide the limbs into four distinct parts: shoulder, forearms, wrists and paws. Then sketch the back legs, one outstretched, the other scrunched in anticipation of making another big bounding leap. This little jackalope seems to be in a hurry—is something chasing it?

5 Draw the Facial Features and Antlers

Draw the eye wide and alert, with a small oval highlight. Darken and extend the upper eyelid to make a worried expression. Draw the antlers sprouting from the top of its head, using surface lines to visualize the form. Sketch guidelines angled the same direction as the rest of its facial features to align the tips. Add some fluff to the inner ear. Don't forget the buckteeth!

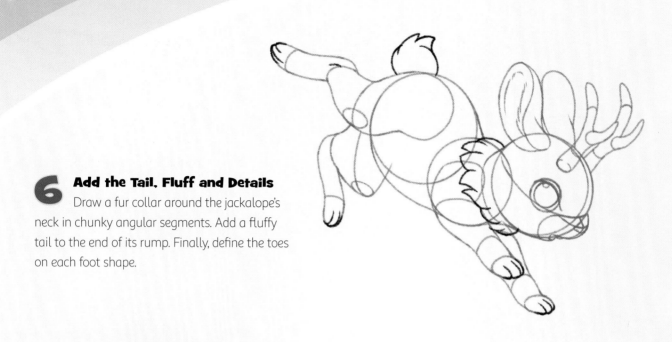

6 Add the Tail, Fluff and Details

Draw a fur collar around the jackalope's neck in chunky angular segments. Add a fluffy tail to the end of its rump. Finally, define the toes on each foot shape.

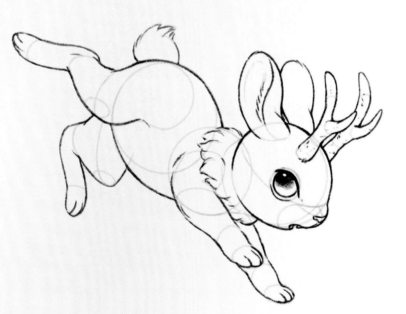

7 Refine Lines

Darken the outer contour and erase any guidelines. Use a light touch on the fuzzy parts (neck, tail, inner ear). Fine lines suggest a soft texture. Shade the pupil area of the eye. Finally, add some dashed lines to the antlers for a rough bony feel.

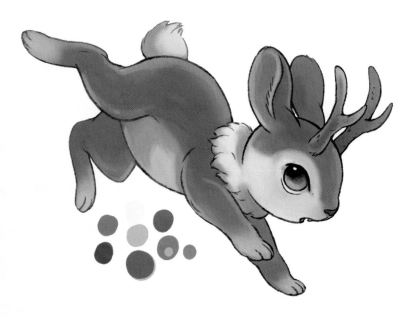

8 Pick Colors

Decide on a color palette for your lil' jackalope. Earthy brown tones are typical for bunnies and offer effective camouflage. You can also try blending a color like purple into the fur to give it a magical quality. Divide the coloration of the fur into two tones: creamy white for the tummy, tail, toes, ruff and lower face, and darker brown for the rest.

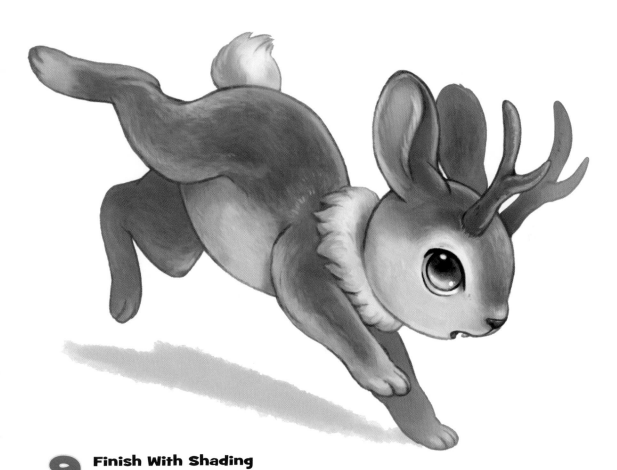

9 Finish With Shading

Build up the shadow tones under the belly and legs. Then go back over the area with darker and lighter tones, using brisk brushstrokes to create the fur texture. Use this technique on the antlers as well to create small crags and pits. Smoothly blend the colors for the eyes, and dot them with white for a glossy glimmer. Use a cast shadow to show a creature's relationship with the ground. Now it's clear only the front paw is touching.

Baby Yeti

The legendary yeti (also known as the Abominable Snowman) is the winter weather cousin to the more temperate Bigfoot. A dense layer of shaggy white hair covers the apelike humanoid from head to ankle and protects it from the freezing temperatures of its lofty mountain abode. Their large feet assist in long treks through deep snow. Adults grow to an average height of 6' 8" (2m).

Baby yetis are highly dependent on their mothers for milk and warmth, and are almost inseparable for the first year. Once they become steady on their feet, they become more rambunctious, finding joy in stomping around the snow and sliding down slopes on their bellies.

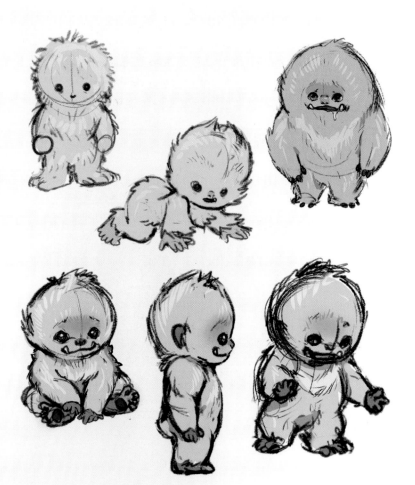

Plan the Design

Because the yeti is a humanoid creature, poses that remind us of human babies such as crawling or learning to walk are especially effective. Keep in mind that yetis have hair all over their bodies—how thick and how the hair is arranged will dramatically affect its proportions. Compare the evenly fuzzed, big footed yeti on the upper-left versus the top-heavy design on the upper-right.

YETI STATS

SPEED:	**1**
STRENGTH:	**3**
MAGIC:	**1**
CUNNING:	**1**
SPECIAL ABILITY:	**IMMUNITY TO COLD**

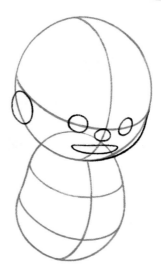

2 Draw the Body

Sketch a large circle for the head. This yeti's attention is directed toward the ground, so draw the crosshairs with a downward tilt. Draw the body as a sturdy bean shape. Draw a center line down the middle. Further divide the bean with horizontal lines to create the chest, midsection and hips.

3 Build Up the Head

Sketch two round eyes along the horizontal guideline. Centered between them, beneath the horizontal guideline, sketch an oval for the nose. You can also use an oval shape for the ear. Draw the mouth stretching wide from eye to eye. Finally, round out the edge of the face with a pudgy baby cheek.

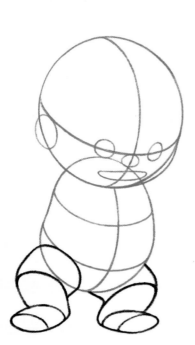

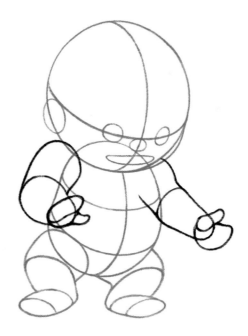

4 Sketch the Legs

Sketch the legs using tube shapes, starting from the hip guideline. Focus on the inner structure of the legs for now, not the fluffy outer layer of yeti hair. Draw the legs bent in a wide gait, like a toddler learning to walk. Divide the leg shape into upper, lower, foot, and toe sections.

5 Sketch the Arms

Sketch the yeti's arms outstretched to catch itself in the event of a tumble. Make the arms nearly twice as long as its legs, similar to an ape's anatomy. Sketch each hand as a simple mitt shape, with a thumb at the end. Don't worry about individual fingers yet.

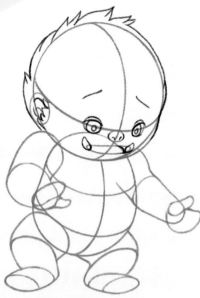

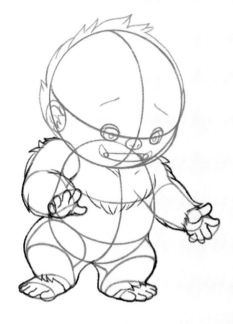

6 Draw the Facial Features

In the yeti's open mouth, sketch a pair of wonky, misaligned tusks (baby's first teeth!) and a tongue. Draw the eyes with slightly lowered lids for a downward gaze. Raised eyebrows convey its uncertainty. Add flaring nostrils to the nose. Detail the inner ear, followed by a bit of hair in front. Finally, fuzz out the top with some wild hair!

7 Add Hair and Digits

Cover the yeti's chest with a dense patch of hair. Fluff out the shoulders, and let the hair hang from the arms and legs. Draw the hair in chunky segments, with occasional up-tilted tufts for a slightly disheveled look. For hair inspiration, look at shaggy polar bear fur. Divide each of the hand mitts into four wiggly sausage fingers. Then add five toes to the end of each apelike foot.

8 Refine Lines

Carefully go over your lines to create the final draft. Allow the hair to have some broken lines for a softer feel. Darken any furrows where fluff collides such as where the shoulder rubs against the face. Erase your guidelines.

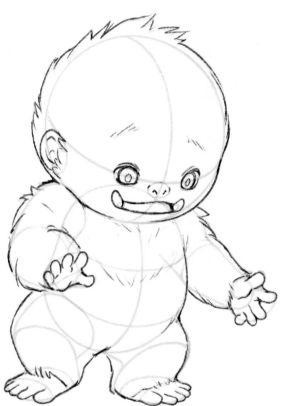

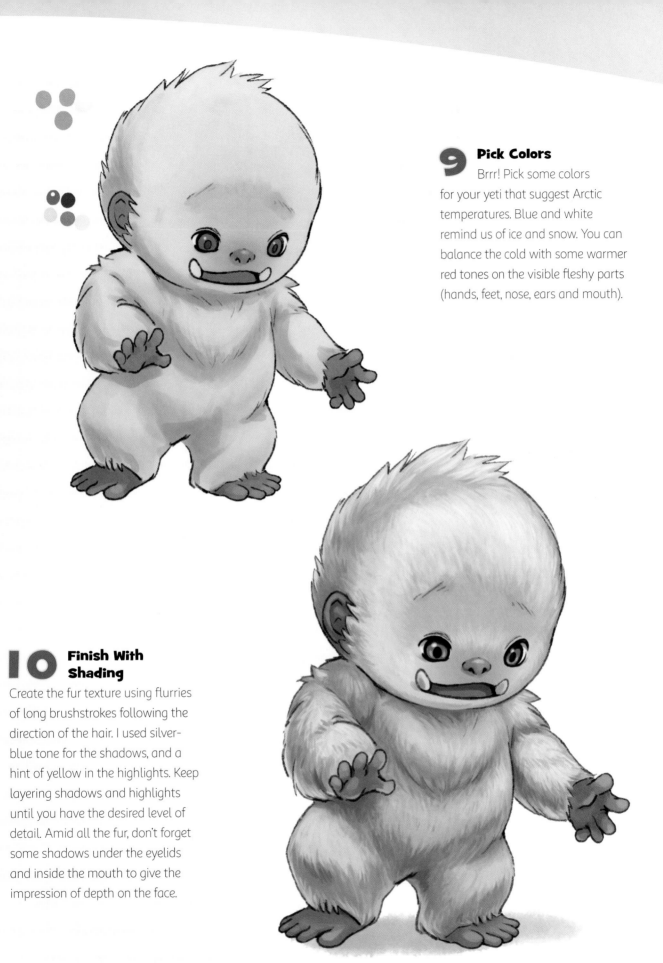

9 Pick Colors

Brrr! Pick some colors for your yeti that suggest Arctic temperatures. Blue and white remind us of ice and snow. You can balance the cold with some warmer red tones on the visible fleshy parts (hands, feet, nose, ears and mouth).

10 Finish With Shading

Create the fur texture using flurries of long brushstrokes following the direction of the hair. I used silver-blue tone for the shadows, and a hint of yellow in the highlights. Keep layering shadows and highlights until you have the desired level of detail. Amid all the fur, don't forget some shadows under the eyelids and inside the mouth to give the impression of depth on the face.

Baby Gargoyle

Urban beasts stationed on buildings by cautious landlords to ward off evil, gargoyles rest in the form of statues during the day, but come to life at sunset. Their hardened flesh makes them resistant to most physical attacks, and, although they are as heavy as stone, they can glide short distances using their wings, and climb a structure's façade with their concrete claws. Despite their intimidating appearance, gargoyles are fine-mannered and fiercely loyal to the inhabitants within their protected territory.

Gargoyles are hatched from eggs, generally from a clutch of one. They can also be magically animated from stone. Baby gargoyles play an active role in guarding their home alongside their parents as they learn basic survival skills. As they grow, they periodically molt, shedding their skin in a shower of stones from their rooftop perches. When they reach about six months old, most depart to find a place of their own to watch over, but a rare few choose to stay and defend their original dwelling.

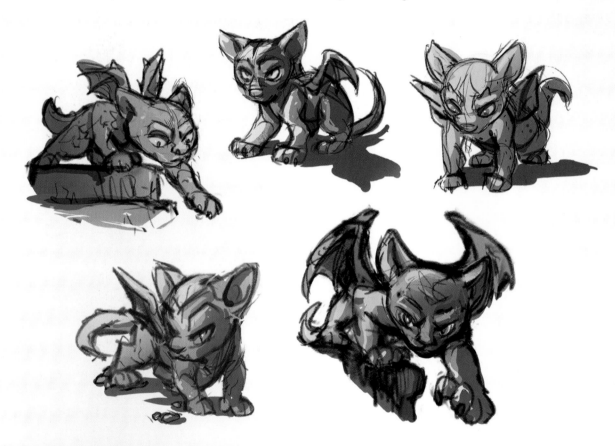

Plan the Design

As a newly appointed guardian, the baby gargoyle prowls its perch with uncertainty. Gargoyles come in a multitude of forms from monstrous to mundanely animal-like, so there are a lot of design possibilities. This particular gargoyle is feline-inspired. Regardless of its form, be sure to emphasize its stony texture. As you explore a variety of wing shapes and sizes, refer to photos of bat wings for inspiration.

GARGOYLE STATS

SPEED:	2
STRENGTH:	4
MAGIC:	1
CUNNING:	1
SPECIAL ABILITY:	**STONE SKIN**

2 Draw the Body

Sketch a large circle for the head, then add the guidelines. Next draw a bean shape for the body. Because the gargoyle is walking towards us, some of the body is obscured behind its head, making it a tricky pose to draw. To keep track of how everything connects, it's helpful to draw even the hidden areas.

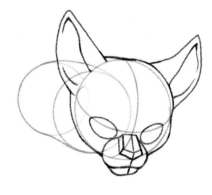

3 Build Up the Head

Build the head shape with rounded cheeks and a squarish top. Sketch a pair of oval-shaped eyes along the horizontal guideline. Then draw a rigid feline muzzle with a triangular nose. Add a pair of large triangular ears at the top of the head.

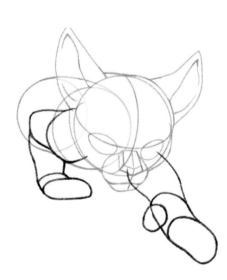

4 Sketch the Front Legs

Sketch the gargoyle's right foot planted firmly on the ground. Exaggerate the size of the left foreleg as it stretches toward the viewer. Foreshortening is an artistic technique for implying and exaggerating depth, making objects appear to recede into the distance. In this case, the outstretched limb looks comparatively large to other body parts set farther back from the viewer.

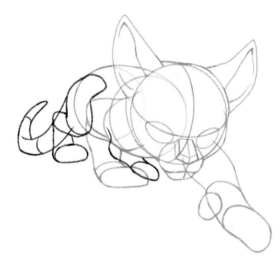

5 Sketch the Hind Legs

Sketch the hind legs creeping along the ground like a cautious kitten. Don't forget the far hind foot, just barely visible behind the front legs. Sketch the tail curling inward to pull the viewer's attention to the figure.

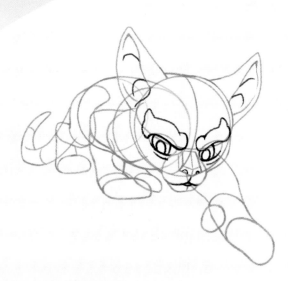

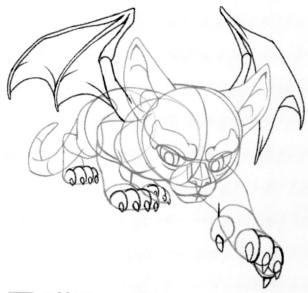

7 Add Wings and Paws

Sketch the bony structure of the wings extending from the shoulders. Though bat wings are comprised of many segments relating to the arm, wrists and fingers, you can simplify the structure into two "fingers." Connect them with an inner membrane. Divide each paw into four digits, plus thumb on the forepaws. Keep in mind some of the digits won't be visible due to the viewing angle. Add a sharp claw to the end of each digit.

6 Draw the Facial Features

Draw the eyes with a downward gaze as the baby gargoyle surveys the edge of its territory. Heavy sculpted brows add a monstrous quality. Add inner creases to the ears and draw the nostrils. Sketch the mouth slightly agape, casting a shadow of cautiousness across an otherwise fierce-looking face.

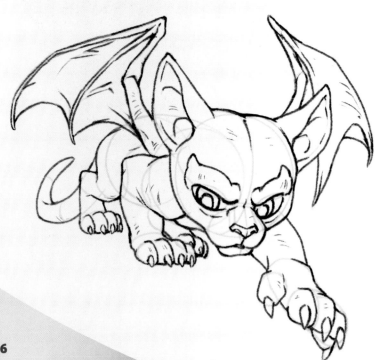

8 Refine Lines

For the final draft, use angular lines and sharp edges to create the feeling of a creature chiseled from stone. Darken the underside of the brow and add some craggy hatched lines for additional texture. Erase your guidelines.

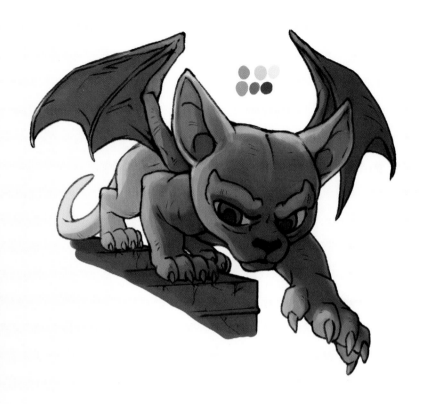

9 Pick Colors

Dark colors like gray and brown are solid choices, but just as stone comes in many shades and textures, so too can gargoyles. Perhaps your gargoyle was sculpted from pink granite, polished marble or even a precious gemstone? Pick your colors and decide on the direction of the light. Backlighting can make a creature look especially ominous.

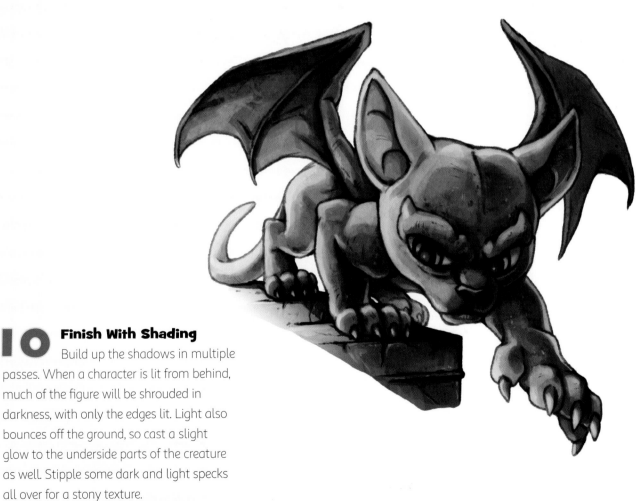

10 Finish With Shading

Build up the shadows in multiple passes. When a character is lit from behind, much of the figure will be shrouded in darkness, with only the edges lit. Light also bounces off the ground, so cast a slight glow to the underside parts of the creature as well. Stipple some dark and light specks all over for a stony texture.

Chimera Cub

A chimera is a peculiar sight. An unfortunate amalgam of creatures bound by magic, their combinations vary, but often consist of a predator, prey animal, serpent and something winged. (Our chimera is comprised of a lion, goat, snake and dragon.) The quadruped creatures often share the trunk, appendages and neck-space in some combination or form, while the serpent migrates to the tail. Winged creatures are often wholly subsumed in the entanglement, aside from their flight-bearing contributions. Often, all of the monster's heads are capable of breathing fire or other elemental magic. None seem happy about their circumstances.

Baby chimeras aren't born, they're made. Each is engineered from several infant creatures, fused together through a flesh-binding process of alchemy. Though the parts live and grow as one, they retain the tendencies, demeanors and tensions of their species, all broiling within their communal body. Saying there's "sibling rivalry" between the heads is an understate-ment. They fight over everything: who eats first, who controls the body and where to go next. Chaotic and tormented, they aren't above lashing out with fire or fang at each other or anything that crosses their path.

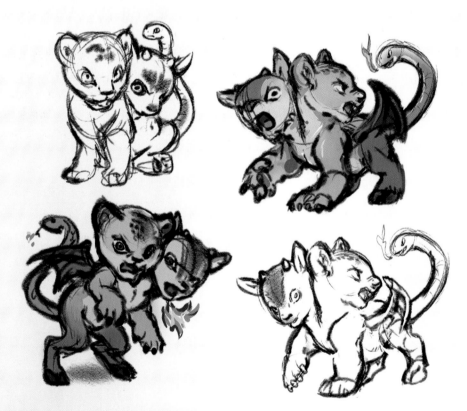

Plan the Design

Our primary goal while sketching designs for the baby chimera is to find the right balance for the various parts. For example, should the body be wholly lion or part goat? How should the heads be positioned? Classical imagery of chimera show a goat head sprouting from the midsection, but both heads side by side provide a nice balance. You'll also need to decide how the dueling personalities interact with each other.

CHIMERA STATS

SPEED:	**3**
STRENGTH:	**4**
MAGIC:	**2**
CUNNING:	**1**
SPECIAL ABILITY:	**ELEMENTAL MAGIC**

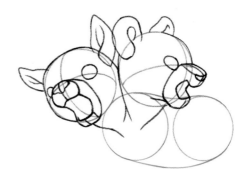

2 Draw the Body

Draw two circles side by side for the goat's and lion's heads. Add guidelines to each to indicate the direction of each face. The left (goat) head peers around, while the right (lion) head cranes to the side. Sketch a sturdy torso to support them, using two large circles connected into a bean shape. Make the chest circle especially large to accommodate the shared neck space.

3 Build Up the Heads

Connect the heads to the body with two evenly spaced necks. Along the horizontal guideline of each head, sketch the goat's and lion's eyes. Starting from below the center guideline, sketch their muzzles stretching wide to let out a mighty growl (or bleat). It's helpful to approach the structure of the muzzle like a box: with a front, top, side and interior. Sketch a line down the center of the muzzle, and add their noses. Finally, sketch a pair of pointy ears for the goat and circular ears for the lion.

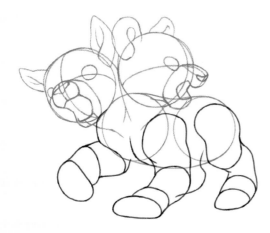

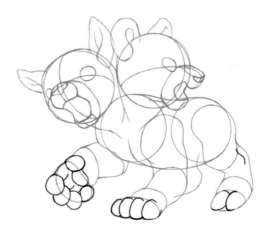

4 Sketch the Legs

This chimera cub's front legs are like a lion's, with big cat paws (and soon, sharp claws), while the hind legs are hoofed, like a goat. Sketch the front legs anchored to a broad chest and shoulders, capable of supporting the two heads. Draw the hind legs connecting from the hip. Indicate the bends at the joints.

5 Draw the Feet

Divide the chimera's left lion paw into four evenly spaced toes. For the right paw, sketch the toes aggressively splayed, plus a thumblike dewclaw. Add a paw pad in the center. Indicate the ankle bone on the hind leg. Finally, split the goat hoof into two pointed toes.

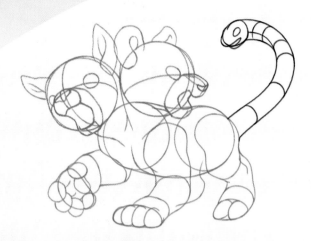

6 Draw the Snake Tail

Draw the tail rising from the goat's rump. Use surface lines to visualize the curvature and turn. Near the head (end of the tail), show the underbelly as the snake twists around to confront its hot-tempered siblings face to face (to face!). Draw the eye with a raised brow and the mouth slightly ajar.

7 Add Facial Features

Draw the eyes, and add pupils—vertical slits for the snake, horizontal slits for the goat and circular pupils for the lion. Sketch the tongues, and then draw four pointy canines in the lion's mouth, a flatter row of teeth for the goat and a pair of fangs for the snake. Draw the nostrils. Give the goat a pair of budding horns. You can make their expressions more aggressive with lowered brows (lions also get creases around the bridge of their noses when they snarl).

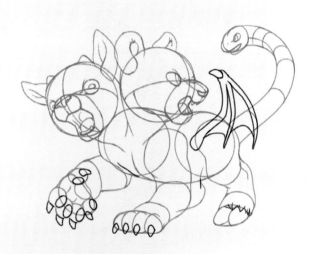

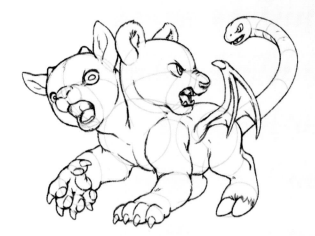

8 Add Details

To give your chimera a lift, stir in a hint of dragon by connecting a batlike wing behind the shoulder blades. Add claws extending from each of the lion toes and paw pads to the underside. Sketch some fur overlapping the hoof. Add some skin folds around the chest and legs.

9 Refine Lines

Tighten up your lines. Darken around creases and lightly shade inside the mouths. Use broken lines to suggest a fur texture, especially around the inner ear, muzzles and elbows. Round out the belly. When you're satisfied with your drawing, erase the guidelines.

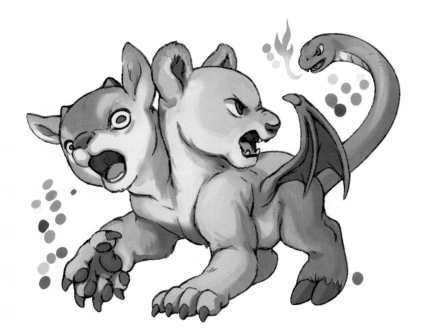

10 Pick Colors

Make a color palette for your chimera. I selected a tawny gold for the lion cub and creamy gray for the goat. To keep the green of the snake from feeling too disconnected, you can echo that color on other parts of the animal, such as the horns and wing tip. Use red tones as an accent and to express a fiery disposition. Begin to build up shadow tones—under the heads, tail, belly, legs, in the inner ear and so on.

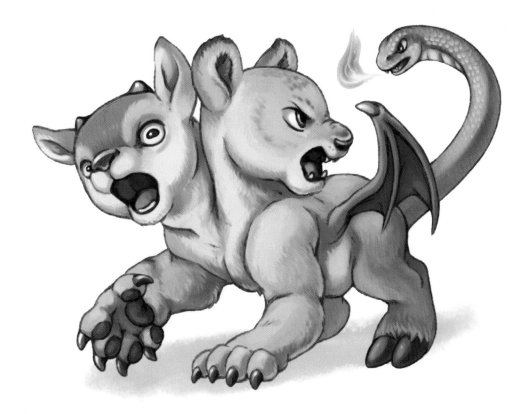

11 Finish With Shading

Suggest the chimera's short fur by using small brushstrokes with a lighter color over a darker area. You can do the same with long hair and longer brushstrokes. Add a scaly texture on the snake by painting shiny oblong scales over the darker green base. Add bright highlights to hard surfaces such as scales, claws and horns, and wet surfaces such as eyes and noses. Finally, for the flame, start with a dark orange-red base, and paint a lighter yellow tone over it.

Red Dragon Hatchling

Dragons roost in numerous corners around the world, though never in great numbers. Most tend to be scaled and serpentine or reptilian in appearance. Beyond that, features can vary depending on the species. The dragon featured here is of the fire-breathing variety, a red dragon with leathery batlike wings. It dwells in caves and other dark places throughout alpine mountainous regions, guarding over its treasure hoards—gold and gems a particular favorite.

Baby dragons hatch from eggs in a clutch of four or five. Not many creatures would challenge a dragon of any size, but adventurers have been known to hunt them, for loot, glory or to protect a precious settlement. A newly hatched dragon, although strong, with fire breath and a mean bite, is particularly vulnerable, as its scales are soft and pliant and won't harden for several months. Fortunately, the mother dragon is never too far away. When a dragon reaches maturity, it leaves the nest to find a new lair for treasures of its own.

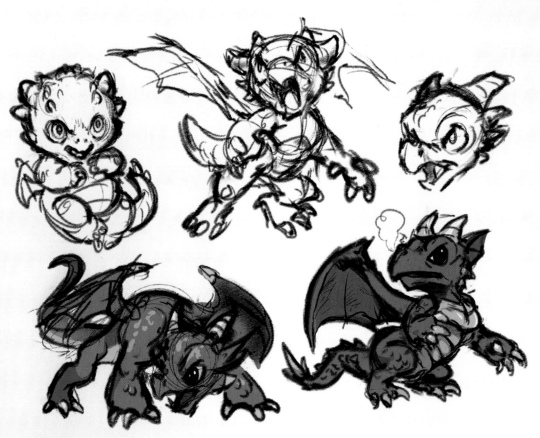

Plan the Design

Explore designs for your baby dragon. Red dragons are hot-tempered and quick to snap (other species range in personality from benevolent to cruel and wicked), so try to reflect that in its body language and expression. Also consider horn placement, wing size and gait—whether it prefers to walk upright on two legs or in a more bestial four-legged fashion.

RED DRAGON STATS

SPEED:	**3**
STRENGTH:	**4**
MAGIC:	**4**
CUNNING:	**3**
SPECIAL ABILITY:	**FIRE BREATH**

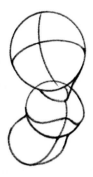

2 Draw the Body

Sketch a pinched-bean torso with a line down the center. Define a rib cage shape from the chest segment. Then sketch a circle for the head. Draw guidelines for an upward head tilt, facing the opposite direction of the body. Connect the head and body with a wide neck, craning to find whatever has caught the dragon's attention.

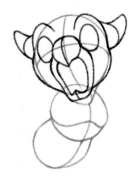

3 Build Up the Head

Sketch a pair of circular eyes along the horizontal guideline. Above them, add a pronounced brow ridge. Fill out the width of the face with the cheeks. Add a pair of stubby, curved horns to the upper sides of the head. From the center of the face, draw the dragon's bulbous beak snout with its mouth stretched in a bellow.

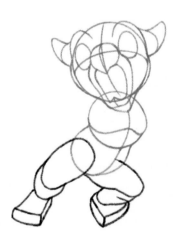

4 Sketch the Legs

Draw the legs slightly bent at the knees—ready to spring into action. Draw the feet as solid rectangular blocks firmly planted on the ground (we'll add the toes later). Indicate bends at the knees and ankles.

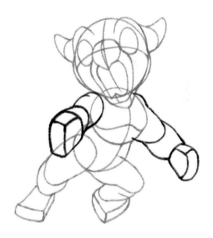

5 Sketch the Arms

Sketch the arms spread wide, threatening to strike anyone who comes too close. Divide the arms into upper, lower and hand segments. The dragon's right arm is coming toward us, so there's a great deal of foreshortening at play. Note the way the arm appears shorter, while the hand is greatly enlarged.

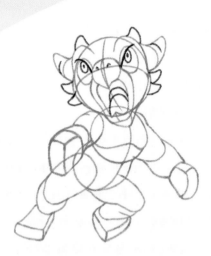

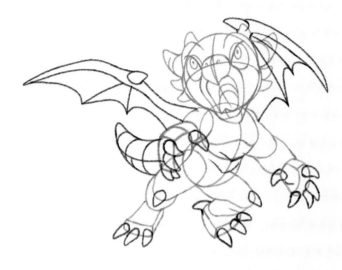

6 Draw the Facial Features

Draw the eyes with pinpoint pupils and lowered lids for a scowl that says, "Don't mess with me!" Add smaller horns around the primary pair. Lizardlike frills and crests are another option. Sketch the inner mouth details. Don't forget a pair of nostrils on the snout.

7 Add Wings, Claws and Horns

Draw rounded claws for the dragon's fingers and toes. I opted for four fingers and a thumb on each hand and four toes on each foot (three in the front, one in the rear), but you may prefer a different arrangement of digits. Add a jutting spike on each knee. Sketch the wings spread in an aggressive posture. Draw a chunky tail with a line along the middle to divide the top and bottom. Finally, add some overlapping plates on the torso.

8 Refine Lines

Do a final pass on your drawing, adding any remaining details as you work your way through the figure. When you're ready to erase your construction lines, be careful to leave any lines that might help indicate creases, bony ridges, scaly plates or areas of overlap.

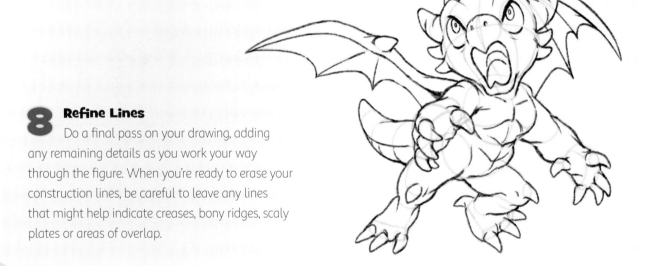

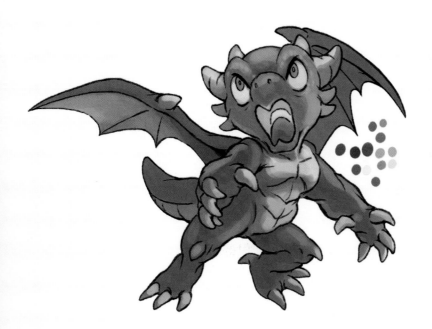

9 Pick Colors

Dragons come in many colors, each with a corresponding temperament and element. This is a baby red dragon, so our color palette consists mostly of red and its neighboring tones. Choose a secondary color (I went with yellow) for the claws, horns, plated torso and tail sections to differentiate from the dragon's other scaly skin. Use duller colors to de-emphasize body parts that stretch into the distance (such as the left wing and tail). This also helps separate similarly colored objects or otherwise confusing juxtapositions of shapes.

10 Finish With Shading

Build up the shadows and highlights. Apply bright yellow highlights in a dappled pattern to suggest tiny scales. Use sharp contrast, going from dark to light with a pronounced edge between the colors, for hard surfaces such as horns, claws and plating. Use softer shading for forms such as the inner wing membrane. Give the inner part of the mouth a bright yellow glow to suggest a burning interior (and imminent fireball).

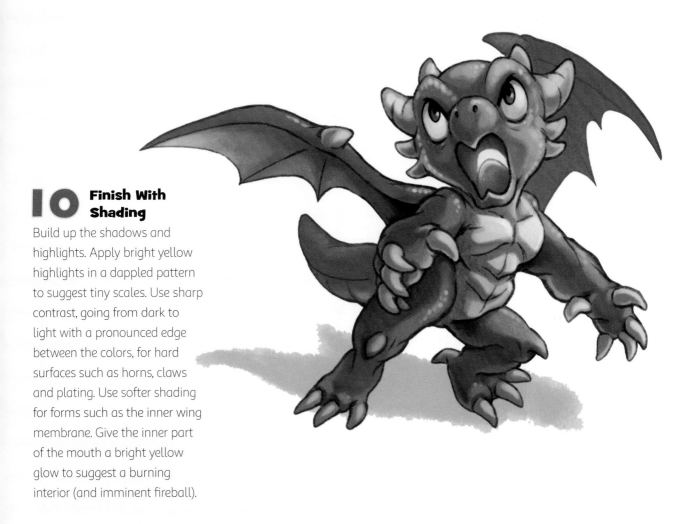

Harpy Chick

A harpy is a petulant avian creature with a humanoid female body and birdlike features. They have wings in place of arms, clasping raptor talons for legs and a beak for a mouth. Harpies perch and observe, plaguing any who ruffle their feathers with an assortment of torments, ranging from petty thievery and harassment, to even carrying off the offending party to places unknown.

Harpies are an all-female species. The chicks hatch from eggs in a large community nest, and are cared for by a squawking sisterhood. While the offspring may display some traits from their father, such as eye color, flesh tone or demeanor, they are always born as a feathery female harpy.

Plan the Design

Explore poses for your harpy chick. Perhaps you can show her swooping through the air and flapping her wings, practicing crucial flight techniques, or learning to grab things with her talons. Study various species of birds for wing, talon and beak inspiration, and then combine the "fowl" features however you see fit.

HARPY STATS

SPEED:	**4**
STRENGTH:	**2**
MAGIC:	**1**
CUNNING:	**4**
SPECIAL ABILITY:	**FLIGHT**

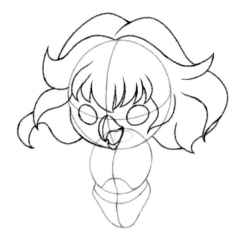

2 Draw the Head and Torso

Draw a large circle for the head. Then draw guidelines to indicate a slight downward head tilt. Next sketch the chest as a circle. (The neck area will be obscured by the overlapping head.) Then indicate the rib cage. Sketch the lower torso divided into hip and stomach sections.

3 Build Up the Head

Draw a pair of circular eyes along the horizontal guideline. Extend the cheeks to give the face a more rounded appearance. Sketch the general shape of the hair in large sections; keep it flowing and light as a feather. Sketch the beak (unless you prefer to substitute a human nose and mouth for a classical harpy look) open with a sneer.

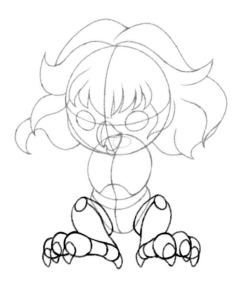

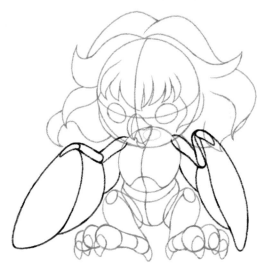

4 Sketch the Legs

Use tube shapes for the legs and feet. Indicate the kneecap with a small circle. Divide each foot into three front toes and a rear toe. Then add the talons.

5 Sketch the Wings

Draw the wings extending from the shoulders. Hidden beneath all the feathers, bird wings are similar to human arms, with shoulder, elbow and wrist joints. You can draw this underlying structure using simple tube shapes. Divide the feathers into three sections: primaries (connecting from wing tip to wrist), secondaries (from wrist to elbow) and axillaries (from elbow to shoulder).

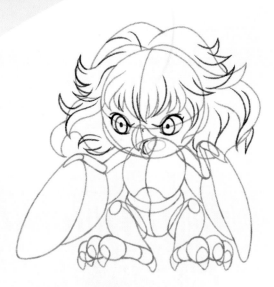

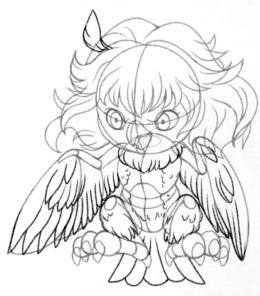

7 Add Feathers

Starting from the wing tip and working inward, draw each feather so it overlaps the next. Layer a light coating of feathers over the body and legs. For extra fluffiness, ring a feathered ruff around her neck. A single feather in the hair makes a nice accent. Sketch the tail feathers fanning out.

6 Draw the Facial Features

Draw the eyes with small, piercing pupils. Darken the eyelids and draw the eyebrows lowered to intensify her intimidating stare. Detail the beak with a tongue and nostril. Feather the hair into more strands, following the flow of each section.

8 Refine Lines

As you tighten your lines, use strong angular strokes to give the harpy a menacing quality. Bump out the front talons. Use bold lines to create depth, making nearer parts pop over those farther back (for example, the feet overlapping the tail). Don't forget the belly button. Erase any guidelines.

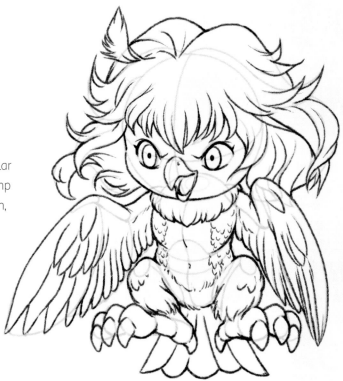

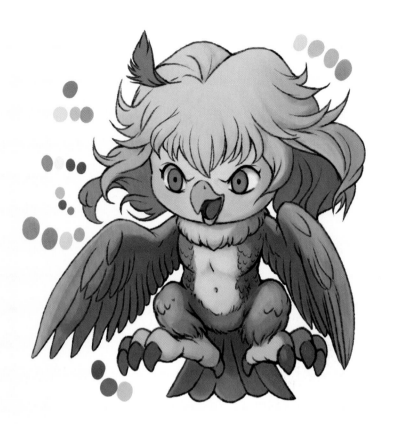

9 Pick Colors

Even among chicks of the same clutch, harpy plumage ranges from bright pigments such as pink, blue, red and yellow, to subdued tones like brown and white, so have fun with your color choices! I chose a palette of blues for this harpy, with steel gray for the talons and yellow for the beak and feet.

10 Finish With Shading

Build up the shadows and highlights with an overhead light source in mind. Use deep shadows on the inner wings, and the underside of the hair and tail feathers. Shine up the beak and talons with sharp highlights. Adding some extra detail in the eyes can give your harpy a striking look.

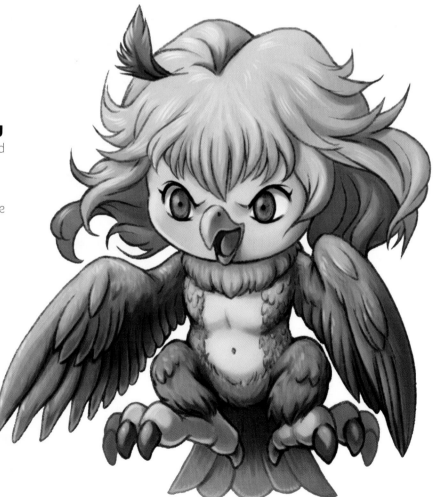

Hippocampus Foal

Covered in shiny scales, with fins instead of fur, the hippocampus is an aquatic creature with the upper half of a horse and lower half of a fish. Hippocampi glide through the water using flipperlike membranes attached to their forelimbs and a powerful serpentine tail. Like their land-based equine equivalents, these seahorses often toil as beasts of burden for undersea denizens, though many still swim free. Adaptive gills augment their mobility, allowing them to breathe in both fresh and salt water.

Baby hippocampi, also known as water foals, hatch from eggs in the shallows, where they learn swimming skills from their mother mares. They grow quickly to keep up with the roaming herd as it travels the seafloor, ever grazing on underwater grasses and vegetation.

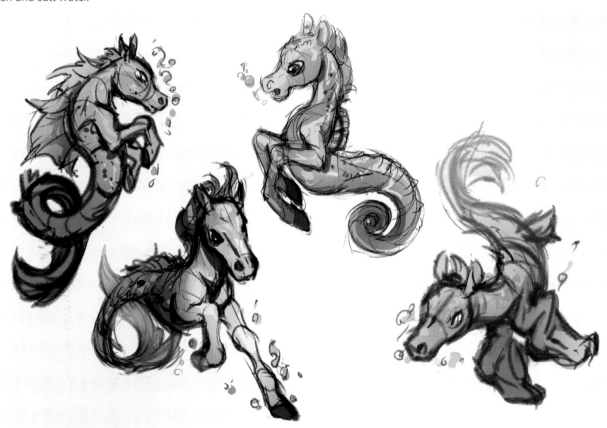

▌ Plan the Design

There are plenty of design possibilities for your aquatic foal. You can glean inspiration from fish, seahorses and other aquatic creatures for scales, ridges, fins, coloration and other features. Some interpretations of the hippocampus retain the horse's forelegs, while others substitute flippers for hooves.

HIPPOCAMPUS STATS

SPEED:	4
STRENGTH:	2
MAGIC:	1
CUNNING:	1
SPECIAL ABILITY:	UNDERWATER MANEUVERABILITY

2 Draw the Head and Chest

Sketch a circle for the head, and add horizontal and vertical guidelines for the face. Then sketch a larger circle for the chest. Connect the two circles with a long tube-shaped neck.

3 Build Up the Head

Along the horizontal guide, draw an almond-shaped eye. Sketch a rectangular muzzle extending from the center of the guidelines. Bump out the foal's brow and cheeks to sculpt the shape of the face. Following the path of the cheek to the top of the head, sketch a pair of ears. Horse ears have a rounded base that narrows to a sharp tip.

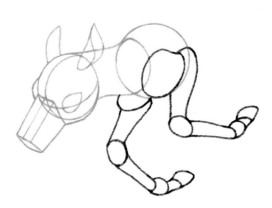

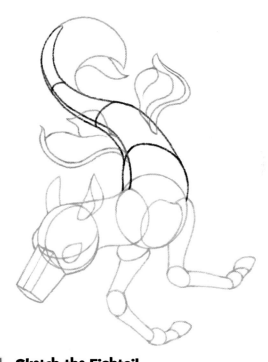

4 Sketch the Forelegs

Starting from the rounded shoulders, sketch the forearms as long cylinders. Next draw each "knee" (anatomically its wrist) as a sphere. Then there's the cannon bones (also cylinder shapes), followed by the fetlocks (a sphere). Finally, the tube-shaped pasterns connect to the hooves.

5 Sketch the Fishtail

Sketch a sweeping line following the spine to capture the motion of the tail. Then build up the tail as a long tapering tube, and adorn it with a flowing fin. Sketch a billowing dorsal fin along the spine. Where the hind limbs would be on a horse, add a pelvic fin. (Like legs, they come in pairs, but the far one is hidden.) The hippocampus's forelegs take the place of pectoral fins, but you can add extra fins for flair or function if you like.

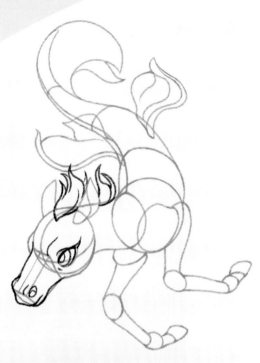

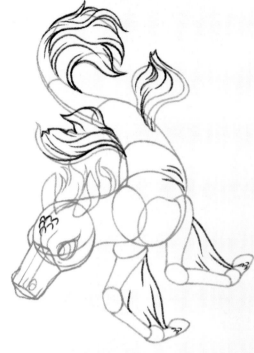

6 Draw the Facial Features

Round out the muzzle, pulling in the underside and jutting out the lips and chin. The nostril looks like a "6" when relaxed (flaring to an "O" when excited or curious); add a ridge along the top. Sketch the fin-mane, flowing from the forehead and top of the neck. Draw the eye, large and expressive, with long lashes.

7 Add Details

Fill out the tail fin with flowing fringes. Add fold lines to the rest of the fins, following their overall form. Add some webbing to the forelimbs, attaching from the elbows to the hooves, to turn them into functional flippers. You can decorate the body with rows of scales, or place them selectively as an accent (as shown here on the forehead). Add a few lines across the chest for gills.

8 Refine Lines

Tighten your line work and darken areas with creases, such as where the legs bend or the chest overlaps the tail. Remove the inner leg lines so the flippers become a unified form. Erase your guidelines, but leave faint indications of body lines beneath the fin membranes for the feel of semitransparency. Draw some bubbles to complete the underwater scene. They don't need to be perfectly round; irregular shapes add visual interest and motion.

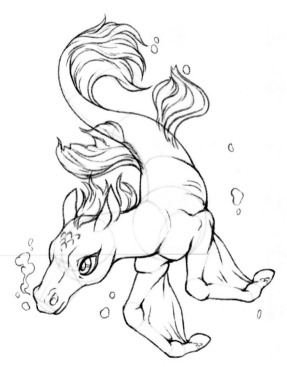

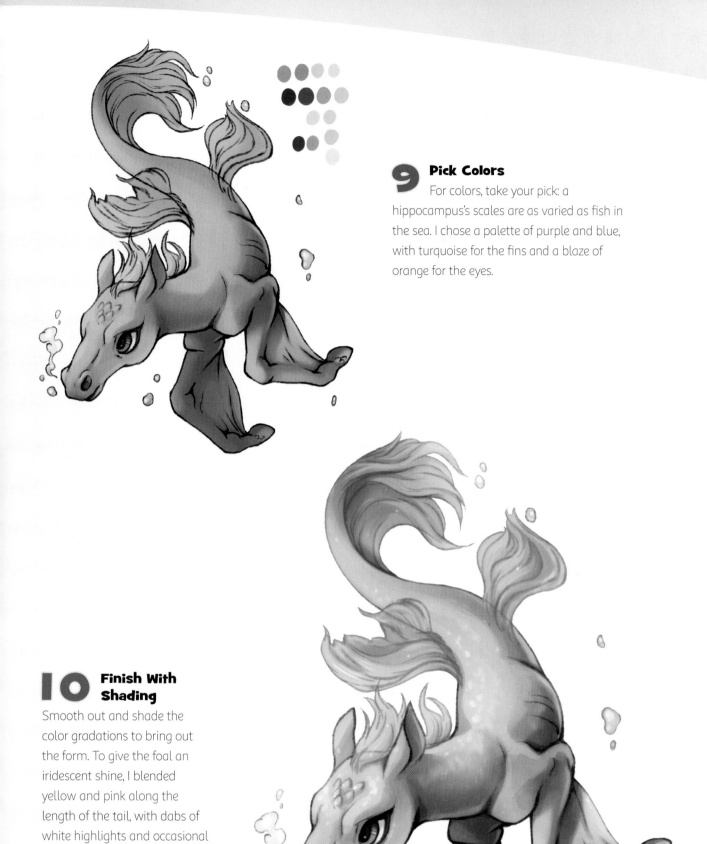

9 Pick Colors

For colors, take your pick: a hippocampus's scales are as varied as fish in the sea. I chose a palette of purple and blue, with turquoise for the fins and a blaze of orange for the eyes.

10 Finish With Shading

Smooth out and shade the color gradations to bring out the form. To give the foal an iridescent shine, I blended yellow and pink along the length of the tail, with dabs of white highlights and occasional spotted scales for shimmer. Give the fins a translucent quality by blending colors where the body beneath shows through.

Fenrir Pup

Fenrir, a giant wolf monster born in a commingling of terrible forces, was destined for trouble. Even as a pup, Fenrir had already grown larger than an adult wolf and far more dangerous. Growing ever bigger, many feared that Fenrir would someday grow so large that he would destroy the world and devour the sun.

To prevent the world's destruction, powerful beings conspired to bind Fenrir in chains, but each time he easily broke free. Finally, they turned to the most skillful of craft creatures, the dwarves, who created the magical chain, Gleipnir. Through deception, Fenrir became ensnared by the delicate but unbreakable chain. He thrashes and howls with rage, but, the more he struggles, the tighter his bonds become. Despite his plight, Fenrir continues to grow. Whatever will become of him, we cannot say.

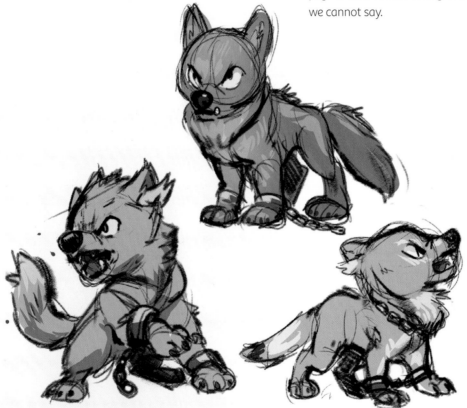

Plan the Design

As a starting point for Fenrir's puppy design, study wolf pups. That said, Fenrir is no average wolf, so you'll want to exaggerate his features to make him "larger than life." Try a bulbous nose, thick claws, powerful gnashing jaws, oversized feet and extra fluff (aww!). For accessories, I gave him an untethered chain and ankle cuffs—remnants of early attempts to restrain him.

FENRIR STATS

SPEED: **4**
STRENGTH: **5**
MAGIC: **1**
CUNNING: **3**
SPECIAL ABILITY: **RAVENOUS**

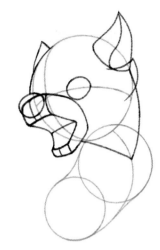

2 Draw the Body

Sketch a large circle for the head. Add guidelines to show Fenrir's attention directed to the left. Sketch a medium-size circle and a smaller circle beneath that, and connect them to create a bean-shaped torso. Draw a curving line across the center of the chest.

3 Build Up the Head

Sketch Fenrir's open mouth using two rectangular shapes set at a 60-degree angle to each other. To make Fenrir look wild and dangerous despite his puppy proportions, use lots of sharp angles. Note the pointed ears and cheek fur; even the neck is a large triangular shape. Contrast this with a touch of cuteness, if desired, by drawing large eyes and a big boopable nose.

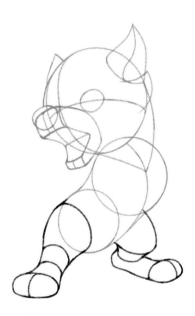

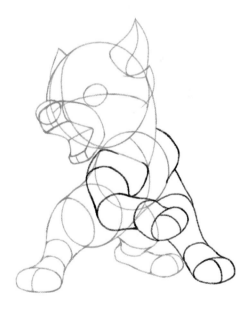

4 Sketch the Hind Legs

Sketch the hind legs in a wide stance, with heels almost touching the ground and equal weighting on each foot, as Fenrir springs into action. Divide the legs into upper leg, lower leg, foot and toe segments. Draw a center line on the paw to create two equal-sized toes (we'll further divide them later).

5 Sketch the Front Legs

Sketch the muscular shoulders framing the neck. Then draw the rest of the forelegs, divided into upper arm, forearm, wrist and paws. Avoid symmetry by drawing the left forelimb pressing into the ground for balance while the other is raised. Draw a line through the center of each paw.

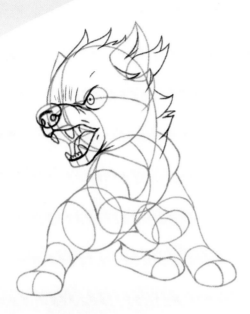

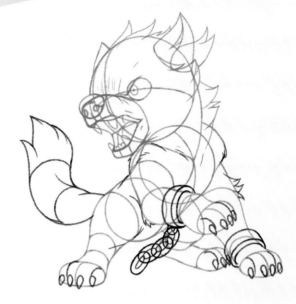

6 Draw the Facial Features

Use brisk, angular lines for the fur along the head, neck and inner ear. Draw a beady eye within the larger eye circle and overlap it with a thick brow line. Add creases to top of the muzzle, and pull the lips into a snarl. Detail the inside of the mouth with four pointy canines, a bottom row of teeth and a tongue. Pulling from the sides to the nose, draw a reverse S-shape to create the nostrils.

7 Add Details

Sketch the tail with a strong curve. Draw extra fur in jagged chunks along the shoulders, elbows and tail tip. Further divide the paw segments so that each has four evenly spaced toes. Cap each toe with a sharp claw. Finally, draw a band encircling each wrist, with a chain of oval loops trailing from the one on the right.

8 Refine Lines

Darken the lines around the eyes, lips, under the neck and the bottom of the paws. Add shading to the inner mouth, nose and nostrils. Erase any guidelines.

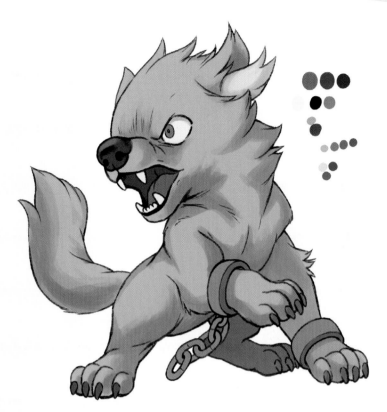

9 Pick Colors

Wolf fur comes in many colors such as black, gray, white, brown, red and silver. Perhaps his coat will darken with time, but for now I went with a cool gray-blue for my rendition of fledgling Fenrir, with red, black and gold as accents.

10 Finish With Shading

Build up the shadows and highlights. Create the fur texture using short, zigzagging strokes, layering light over dark. Use high contrast (placing bright highlights next to much darker tones) on hard, shiny objects such as the chains, claws, nose and teeth. Cast a shadow beneath Fenrir to ground him, for now.

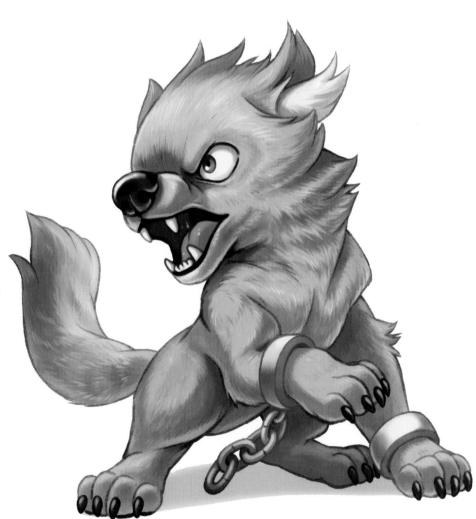

Mini Minotaur

Stubborn, strong and quick to anger, a minotaur has the head of a bull and the body of a titan. The original Minotaur was the child of a bewitched human queen and a giant bull. To confine this dangerous offspring, he was sent to the center of a mazelike labyrinth, where he lived for many years, feasting upon the brave, foolhardy and helpless who found themselves in his domain.

Descendants of the minotaur have an excellent sense of direction and feel most at home in locations with tight corridors and twisting or branching paths. They live in small groups with a chief bull as the leader. While they aren't especially smart, minotaurs can use tools and are capable of human language. Most minotaurs are male, but females occur on rare occasion. Young minotaurs tend to be bullheaded and prone to temper tantrums but can also be quite playful and love a good game of hide-and-seek.

Plan the Design
Do some exploratory sketches of your mini minotaur's design and pose. Look at calves for inspiration. Features might include big glossy eyes, bovine ears and snout, cowlicked hair, cloven hooves, a cow tail and undeveloped horns. You also want to consider the degree of bovine-ness. A minotaur stands on two legs, like a person, but perhaps it also has hooves in place of hands?

MINOTAUR STATS	
SPEED:	3
STRENGTH:	5
MAGIC:	1
CUNNING:	1
SPECIAL ABILITY:	**NAVIGATION**

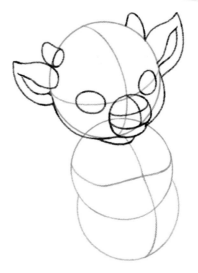

2 Draw the Body

Sketch a circle for the head, and add crosshairs to indicate the direction of his gaze. Then sketch a circle for the chest, and pronounce the pectoral muscles. Draw another circle beneath that for the lower torso. You can erase the top half of the circle covered by the chest. Finally, draw a center line through the torso, welding the two circle forms.

3 Build Up the Head

Sketch a pair of eyes along the horizontal guideline. Between the eyes, draw a short, boxy muzzle. Round out the cheeks. Then sketch the triangular ears, centered along the horizontal guideline on the sides of the head. Directly above them, sketch the horn nubs. Finally, connect the head to the body with a short neck.

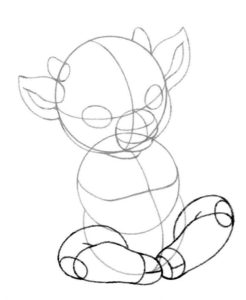

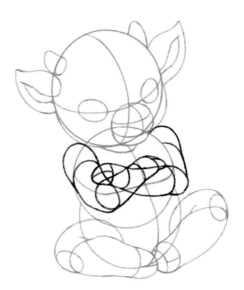

4 Sketch the Legs

Using tube shapes, draw the legs folded in a crossed position. Where the upper and lower leg meet, sketch an oval to indicate the knee. Cap the end of each leg with a cylinder shape, and sketch a line down the center for cloven hooves.

5 Sketch the Arms

The crossed arm position can be a little tricky to draw. Try doing the pose in the mirror first, and observe where your arms overlap and how your hands tuck. Then, starting with the arm closest to the body (in this case, his left) build up the form: muscular shoulder, upper arm, forearm, hand and hoof. Next, carefully draw the right arm so that it fits under the left hoof-hand and over the rest of his left arm.

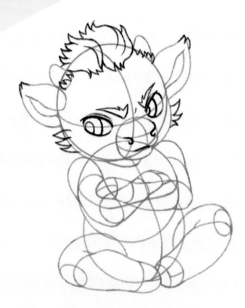

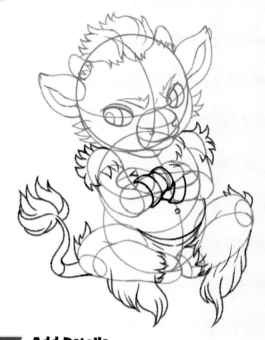

7 Add Details

Fur everywhere! Continue using jagged lines to frizz out the shoulders, chest, hands and legs. Then sketch a tail peeking around the side of his body, topped with a puff of fur. Round out the belly, and add a circular belly button. Constant with their half-human heritage, minotaurs show concern for clothes, so add some gold bands wrapping around his wrists, and don't forget the loincloth!

6 Draw the Facial Features

Give your moody lil' Minotaur a grumpy expression by drawing lowered eyelids and brows and a big frown. Use jagged lines to add coarse fur around his cheeks, horns, ear tips and eyebrows. Draw the nostrils using a stretched C-shape. Finally, top his head with a messy cowlick hairstyle.

8 Refine Lines

Tighten your lines, but leave some broken, open sections around the fur. Darken lines around creases and under areas like the arms, head and belly. Draw the split toes on the hooves. Then erase your guidelines.

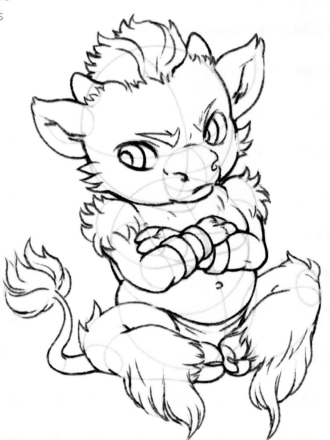

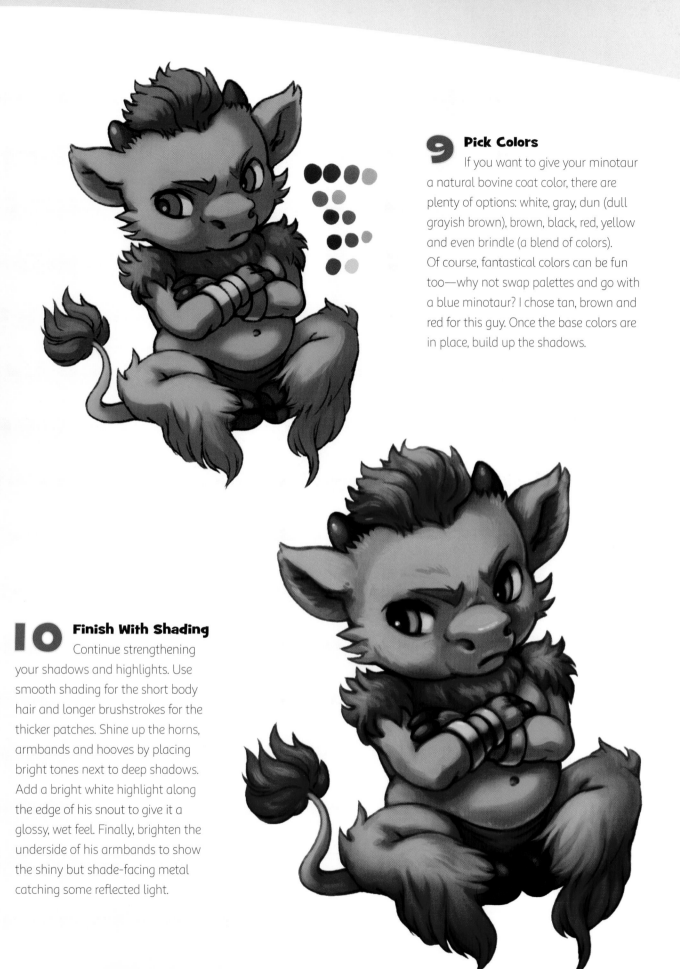

9 Pick Colors

If you want to give your minotaur a natural bovine coat color, there are plenty of options: white, gray, dun (dull grayish brown), brown, black, red, yellow and even brindle (a blend of colors). Of course, fantastical colors can be fun too—why not swap palettes and go with a blue minotaur? I chose tan, brown and red for this guy. Once the base colors are in place, build up the shadows.

10 Finish With Shading

Continue strengthening your shadows and highlights. Use smooth shading for the short body hair and longer brushstrokes for the thicker patches. Shine up the horns, armbands and hooves by placing bright tones next to deep shadows. Add a bright white highlight along the edge of his snout to give it a glossy, wet feel. Finally, brighten the underside of his armbands to show the shiny but shade-facing metal catching some reflected light.

Baby Naga

With a human face, framed by the hood of a king cobra, and the lower body of a serpent, naga are half-snake, half-human celestial creatures. Although most naga possess a kind and benevolent nature, they are venomous (even the babies) and should be treated with caution and reverence. Powerful magic enables them to temporarily shapeshift into a wholly human or snake form, though their blue-tinged skin often reveals their true nature.

Baby naga are born with an egg tooth that falls off upon hatching. They have the same scale and color patterns as their parents but with adorably rounded features and a much shorter tail. As hatchlings grow, they learn how to slither into a humanlike "standing" position, but for the first year they crawl using the motion of their tail and arms to pull them along. Baby naga are very curious and eager to learn and enjoy having a favorite story read to them before bed.

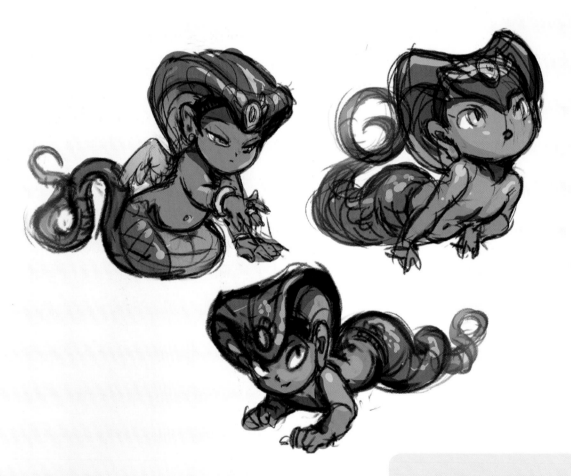

Plan the Design

Study baby snakes, especially king cobras, for scale, patterning and form. Explore poses that simultaneously convey a baby's innocence and wisdom beyond their years. Consider accessories such as jewelry, crowns and belts. Some naga even have wings.

NAGA STATS

SPEED:	3
STRENGTH:	2
MAGIC:	4
CUNNING:	4
SPECIAL ABILITY:	**SHAPESHIFT**

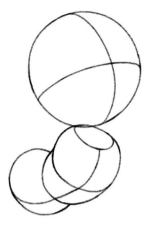

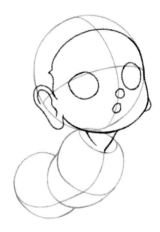

2 Draw the Body

Sketch a large circle for the head. Add guidelines indicating an upward tilt. Draw the torso with a strong twist between the chest and hip segments. Sketch a line down the center to join the body parts, showing their tilt.

3 Build Up the Head

Round out the face shape with cute, chubby cheeks. Sketch a pair of large, upturned eyes along the horizontal guideline. In the center, add a little gumdrop nose and a curious, open mouth. Sketch the ears stretching from above the eye line to the bottom of the chin. Connect the head to the body with a tube-shaped neck. Draw the hair line.

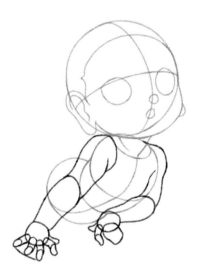

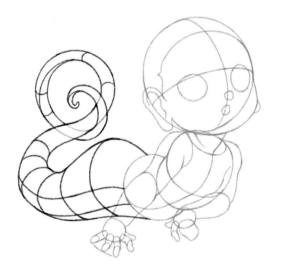

4 Sketch the Arms

Sketch the naga's arms using long tube shapes. Show the left arm bearing its upper body weight while the right arm is outstretched. Draw the fingers of the right hand splayed to help with balance. You can leave the middle, ring and pinky fingers of the left hand as a simplified block for now.

5 Sketch the Tail

Sketch a rough path for the naga's lower snake half to follow. Make the tail curve and overlap for visual interest. Then draw the snake tail as a long tube, using surface lines to build up the shape. Taper the tail as you reach the tip. Draw a pair of parallel lines along the form to indicate the flat belly side.

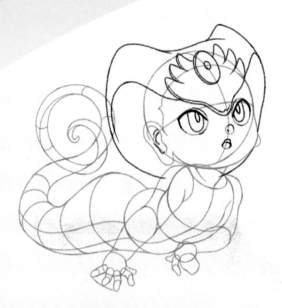

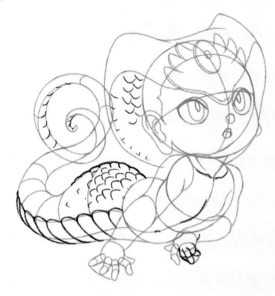

6 Draw the Facial Features

Detail each eye with an inner oval shape and a vertical slit pupil. Draw the eyelids slightly lowered, and go over the lines several times to darken them. Draw the top of the nose, nostril, tongue and inner ear lines. Finally, sketch the large cobra hood, billowing from the top of the head to the base of the neck. Decorate the front of the hood like a lavish bejeweled crown.

7 Add Scales and Details

On the hood and tail, draw some scales as a series of interlocking Cs. You don't need to draw every scale (unless you want to)—several rows are enough to establish a pattern and provide texture. Cover the belly of the snake tail with thicker, platelike scales called scutes. Add a belly button, inner chest fold and a collarbone. Sketch the remaining fingers.

8 Refine Lines

Work through your drawing, refining the linework and erase any guidelines. Emphasize the gentle curving lines and folds of the arms and hands (think baby fat). Darken overlapping elements like the right shoulder, tummy and the crook of the left arm. Add some hatched lines along the tail and hood for a rough scaly texture.

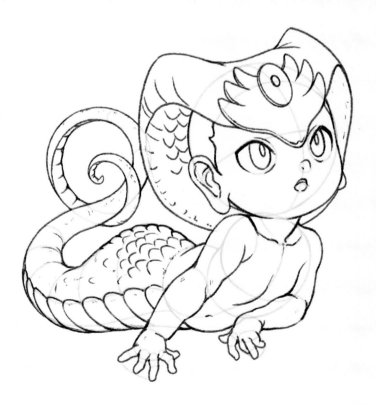

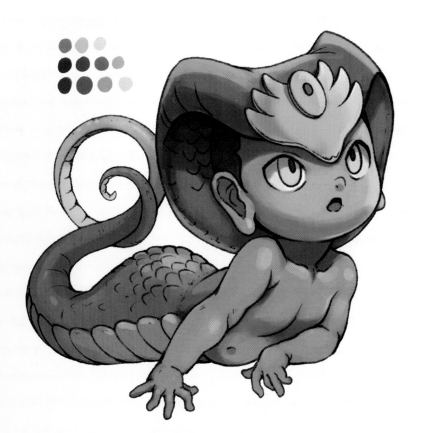

9 Pick Colors

Snakes come in many colors, and naga are magical creatures, giving you almost limitless color choices, though you may want to borrow from nature if you're looking to capture a particular snake's scale pattern. An unnatural skin tone can help set the naga apart from humans (as if the snake tail wasn't enough of a hint), and give it an otherworldly appearance or suggest venomous toxins coursing in its blood. Once you've settled on color, determine the direction of the lighting (front and center on this naga) and lay in the base tones.

10 Finish With Shading

Build up the shadows and highlights, following the established lighting. Use smooth blended colors on the skin, and harder color divisions for the scales. On the crest, play dark against light to capture the feel of metal and blend in tones that reflect adjacent colors. Add a scaly texture to the tail (and just a hint of texture on the skin). Shine up the figure with mirrorlike highlights along the select scales.

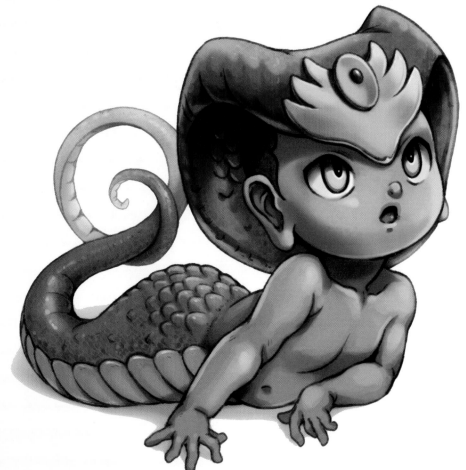

Lil' Kraken

Dwelling deep beneath the seas, krakens are squidlike monsters of legendary proportions. Embodying the nightmares of sea creatures and sailors alike, the largest, oldest krakens appear like living landmasses, easily measuring over a mile from mantle peak to writhing tentacle tip! Huge, aggressive and ever hungry, their slightest jostle can tear a ship apart. They rise to the shallows to devour, then retreat to the depths, leaving massive whirlpools in their wake.

Krakens are solitary creatures and only seek a mate to spawn with at the end of a thousand-year cycle. Though a kraken's melon-sized eggs initially flood the oceans in the millions, by the time of their infancy, all but a few of the defenseless floating food sacks have become morsels for other hungry ocean titans. For the ones that survive, it's sink or swim as they grow and hone their hunting skills. Measuring around 100 feet (30.5m) during the juvenile stage, they start consuming small vessels, such as fishing boats, before moving onto more massive prey.

Plan the Design

Descriptions of krakens vary through history. Some say they look like giant squids, while others claim they are more like octopi or even crabs. I gave the kraken a cephalopod likeness, but added a crustacean twist: a crablike armored shell to protect its delicate mantle. Sketch your kraken in playful poses as it carelessly ravages its world through innocent exploration.

KRAKEN STATS

SPEED:	**3**
STRENGTH:	**5**
MAGIC:	**1**
CUNNING:	**1**
SPECIAL ABILITY:	**MEGA TSUNAMI**

2 Draw the Body

The kraken is a little different from the creatures we've drawn so far, but it starts very simply, with a large circle. Add horizontal and vertical guidelines to indicate the direction of its gaze.

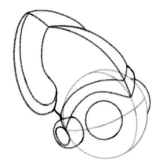

3 Build Up the Head

Sketch a large pair of eyes along the horizontal guideline. On the side of the circle, where an ear might be, sketch a cylinder shape for the kraken's water jet. Next, resting on the top of the circle, draw the kraken's mantle like an arrow-shaped hat. The mantle is a feature of cephalopods, a combined head-body cavity, where all its internal organs reside.

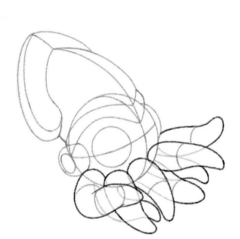

4 Sketch the Arms

A kraken has eight arms like a squid. That's a lot of limbs to keep track of, so take your time. Starting from the center line around the base of the circle, sketch each arm as a long, tubelike shape. It's helpful to draw the entire arm, not just the visible part. Use surface lines to help visualize the forms.

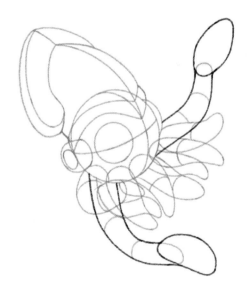

5 Sketch the Tentacles

A longer pair of attack tentacles are used for grasping and passing prey to the kraken's arms (and into its beaklike mouth, hidden from view). Sketch its right tentacle down below, while the left one lifts skyward to inspect its catch. Add a club-shaped "hand" at the end of each. Again, use surface lines to define the tentacle tubes.

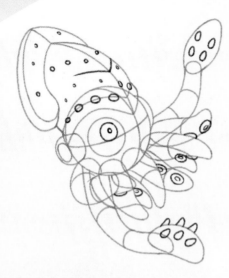

7 Draw the Boat

Use props to help emphasize scale. Here, we see the kraken toying with a small fishing boat, which tells us that this creature, even as a baby, is much, much bigger than your average squid. The tiny fish, barrel and oar offer additional size clues.

6 Add Details

Sketch the inner eye details to give the baby kraken a piercing but curious gaze. Decorate the mantle with some bumpy protrusions. Add suckers to the underside of the arms. At the ends of each tentacle hand, add several rows of sharp hooks. (I skipped the final row on the left hand since they'll be obscured by the boat.)

8 Refine Lines

As you darken your lines, be mindful of how the arms and tentacles overlap. Use broken line segments on the mantle to define its facets without creating fissures between areas. Sketch waves cresting around the kraken's left tentacle and just below the eyes. Don't go too heavy with the water details—we'll save that job for color. Draw the wooden planks of the boat and barrel. Erase your guidelines.

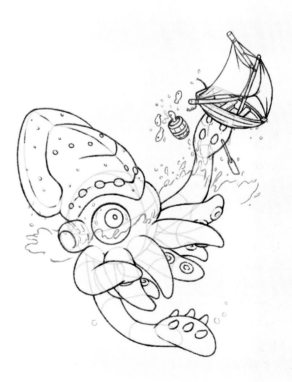

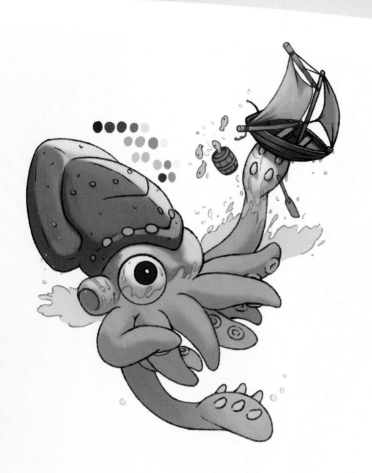

9 Pick Colors

Like squids, krakens can alter their skin colors for camouflage and signaling, so your palette and pattern options are limitless! I picked a crabby-red for the mantle, pink for the flesh and yellow for the eye. For the parts below the water line, blend in blue tones fading to gray to suggest depth.

10 Finish With Shading and Water Effects

Continue to build up your shadows and highlights. To create the water effects, start by glazing areas with dark runny streaks, and then go over them using drippy white dashes and speckles. Dab flecks of foam in the air and along the waterline to suggest waves and splashing as the kraken breaches the surface. Undergird these areas with dark blue ripples for contrast.

Lil' Leviathan

Leviathans are toothy, whalelike creatures with twisting serpentine bodies and mighty fins. Far larger than the largest whale that ever lived; this massive sea monster is many thousands of feet long and can devour enormous schools of fish with a single gulp. As a leviathan swims, the tremendous waves left in its wake have the potential to crush seafaring ships or scour entire coastlines with a tsunami. On the rare occasions when a leviathan surfaces for air, its tremendous scorching spout can send cyclones spiraling through the atmosphere.

A newborn leviathan calf can be several hundred feet long, and continues to grow at a rapid pace throughout its first year. The calf stays by its mother's side during this time, consuming milk, whales and baby kraken. After this, it departs to find an unclaimed corner of the ocean to live the rest of its solitary life, feasting upon and fighting with other aquatic monsters.

Plan the Design

Research aquatic animals like blue whales, beluga and orca. See how they conduct themselves underwater, and incorporate body shape and familiar elements like flippers, flukes and fins to add believability to your design. Be sure to work the leviathan's long, serpentine tail into the pose.

LEVIATHAN STATS

SPEED:	**2**
STRENGTH:	**5**
MAGIC:	**1**
CUNNING:	**2**
SPECIAL ABILITY:	**HURRICANE SPOUT**

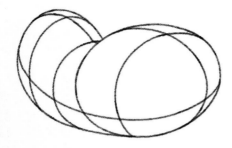

2 Draw the Body

Leviathans have an unusual torpedo body shape, so instead of the typical circle, start with a wide bean shape for the head and body, and divide the segments with a puckered midsection. Draw a line running along the side to indicate the ventral (belly) area. Use additional surface lines to indicate facing and visualize the form.

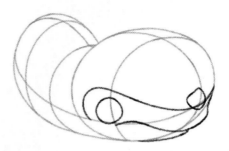

3 Build Up the Head

Sketch a large circle for the eye, centered on the side of the head along the ventral guideline. Expand the front of the face, and draw the massive mouth pulling all the way back to below the eye. Sketch a brow line curving around the eye to the front of the face. Add a small horn nub in the center.

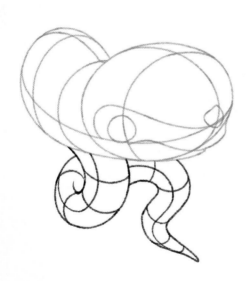

4 Sketch the Tail

Sketch a curving path for the tail, pulling down from the rear of the body and then coiling around. Then fill in the form using a long tube shape. Sketch a line down the length of the tube to divide the tail into top and bottom sections. Add surface lines around the tail to help with the twists and define its descent into the deep.

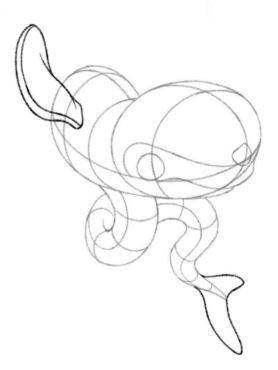

5 Sketch the Flipper and Fluke

Sketch the boomerang-shaped flippers extending from the side of the body. The shape is relatively flat, but with a defined side edge that gives them a curvaceous quality. Add a whalelike fluke at the base of the tail, extending from the sides (as opposed to the top and bottom orientation of a fish's caudal [tail] fin).

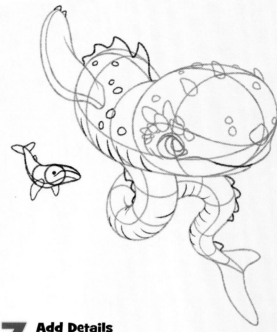

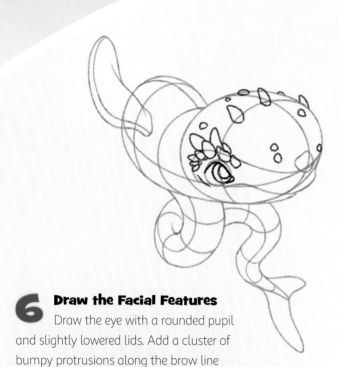

6 Draw the Facial Features

Draw the eye with a rounded pupil and slightly lowered lids. Add a cluster of bumpy protrusions along the brow line and scatter additional bony outgrowths around the face.

7 Add Details

Continue adding bumpy protrusions along the rest of the body. Add a couple of clawlike scales at the end of the flipper. Draw a jagged fin along the top centerline of the body. Indicate some fold lines across the belly, following the curvature of the form. Finally, to emphasize the magnitude of this "little" leviathan, sketch a full grown blue whale (the largest animal known on Earth) swimming beside it.

8 Refine Lines

Use darker, thicker lines to pop the leviathan's head over its tail. Also, darken the lines around the eyes and mouth to emphasize the enormous creases. Add some hatched lines to give the skin a rough texture. Use an occasional broken line along the edge of the belly, flipper and face to create a soft division from topside to fin keel. Erase your guidelines.

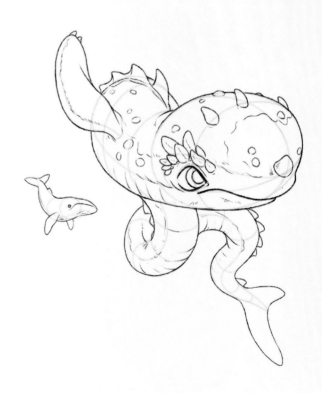

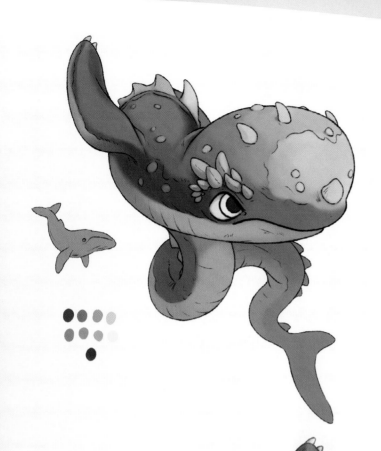

9 Pick Colors

The leviathan's colors are open for interpretation. Common colors for whales are black, gray, gray-blue, brown and white, but, as a fantasy creature, it could just as well be any color you like! Blue tones also make a good choice for an aquatic creature, as they remind us of water. In this case, I opted for a two-tone body, with a dark blue top and light underbelly—not uncommon among whales, sharks and other large sea creatures.

10 Finish With Shading

Add shading to the underside of the leviathan and brighter highlights along the top. Speckle some lighter tones throughout the body to suggest scales. When depicting a creature of epic proportions, atmospheric perspective is your friend! You can suggest that an object is farther in the distance, such as the leviathan's hundreds-of-feet-long tail, by fading the intensity of the colors.

Manticore Cub

With a human's face and intellect, a lion's body, batlike wings and the tail of a scorpion, the manticore is a strange combination of dangers and deceptions. The manticore's name is derived from the Persian words *mardya* and *khowr*, for man-eater. With multiple rows of sharp teeth, it's deserving of the name, and routinely devours humans whole—even the bones! In close quarters, a manticore also uses its barbed tail and sharp claws to defend ... or kill. Their wings are not strong enough for flight, but can assist in jumping and gliding short distances.

Despite the aggressive nature of the adults, especially in regard to humans, a manticore's demeanor toward its family is surprisingly tender. Manticore cubs, born in litters of one to three, are cared for by both the mother and father for the first several years. During this time, they sleep snuggled together in a cozy den, and learn how to hunt while engaging in fun pouncing games. Although the cubs possess stingers, they do not produce venom until they reach maturity.

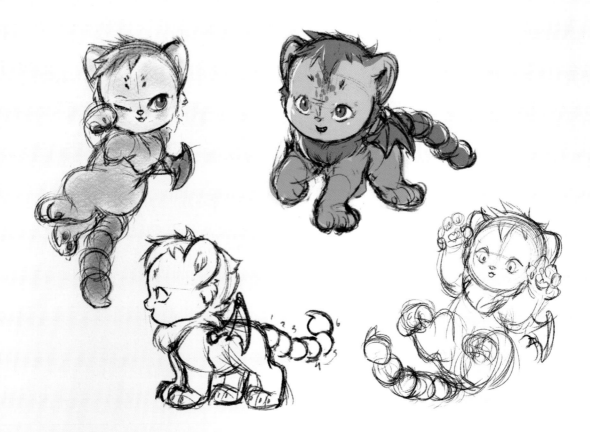

Plan the Design

Sketch your manticore in playful kittenlike poses but with a lion cub's proportions. Give it an expressive face, hinting at human intelligence, framed by a scruffy mane. Don't forget the underdeveloped wings and harmless rounded scorpion tail.

MANTICORE STATS

SPEED:	**3**
STRENGTH:	**3**
MAGIC:	**1**
CUNNING:	**2**
SPECIAL ABILITY:	**POISON STING**

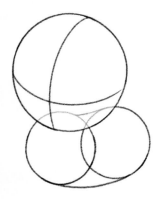

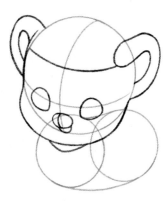

2 Draw the Body

Sketch a large circle for the head, and add forward facing guidelines. Underneath, sketch a bean-shaped body, comprised of two smaller circles. (The upper part of this shape is overlapped by the head.)

3 Build Up the Head

Extend the bottom of the head shape with rounded cheeks. Then connect the head to the body with a short neck. Draw a pair of gumdrop-shaped eyes centered on the horizontal guideline. Add a small rounded muzzle between them. Sketch the round ears on the sides of the head, using a guideline along the forehead to align them.

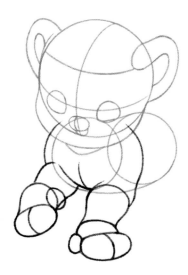

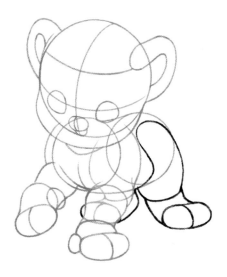

4 Sketch the Front Legs

Draw the front legs, with the left paw planted on the ground while the right paw lifts. Anchor the forelimbs to the chest with meaty shoulders. Denote the bends at the elbows, wrists and paws. Draw a center line through each paw, and define the thumblike dewclaw.

5 Sketch the Hind Legs

Sketch the left hind leg using tube shapes connected at the pelvis. From a front angle, the belly overlaps the leg. Draw the foot with a lifted heel, and sketch a center line through the paw. Then, although it's mostly hidden, sketch the full shape of the right hind leg to ensure its proper placement.

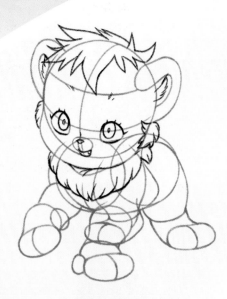

6 Draw the Facial Features

Draw a pair of bright, oval-shaped eyes, and accent the upper lid with tiny lashes. Draw an indent for the nose bridge, and top the muzzle with a triangular, feline nose. Within the open mouth, add a tiny tooth. Sketch some fluffy fur inside the ears. Sketch the cub's developing mane along the top of its head, wrapping around the ears and encircling the neck.

7 Add Details

Sketch the manticore's scorpion tail as six overlapping circular segments. Add a rounded barb to the end. (We want the tail to look cute and nonlethal.) Add a batlike wing behind the shoulder. Divide each paw into four rounded toes. Finish the paws with a tiny claw at the end of each toe, including the dewclaw.

8 Refine Lines

Tighten your lines. Darken underneath the head and belly. Unify the tail shape by allowing an open space to flow through the center of it. Erase your guidelines.

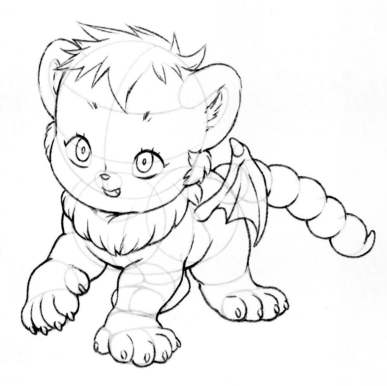

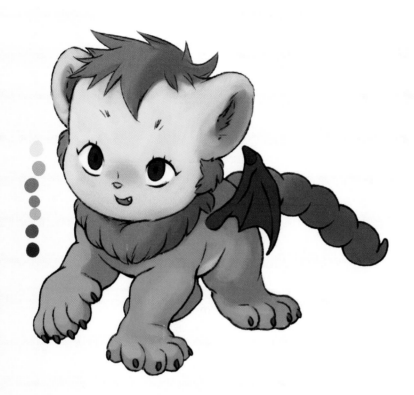

9 Pick Colors

Full-grown manticores have radiant blood-red fur that strikes fear into their prey, while cubs have lighter coats with orangish tones, allowing them to hide more easily among rocks and sand. Use dark accent tones on the claws, wings, eyes and tail for a nice blend of light and dark patches.

10 Finish With Shading

Apply shading with a light touch (no deep shadows) to give the cub a cheery mood. Add some spot patterning along the forehead, and other places if desired. These cute spots will thicken and merge into rigid feline patterns as the cub grows into adulthood, heightening its predatory look. Fade the tail to gray as it recedes into the distance. Add a wet glint to the eyes, nose and claws.

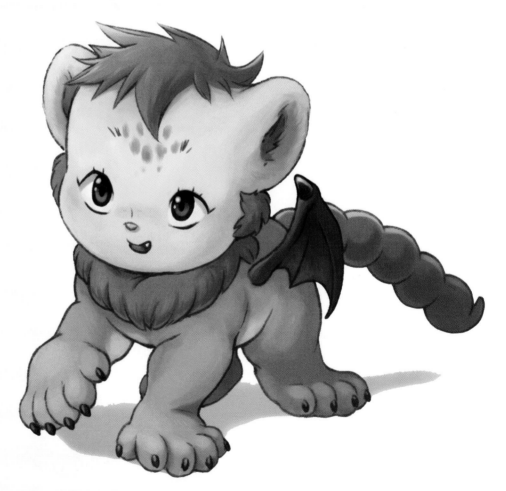

Baby Fairy

A fairy (sometimes called faery or fae) is a magical creature, humanoid in form but tiny—about the size of a rosebud—with pointed ears and delicate insectlike wings. Their magical aura gives them a blue glow that makes them easier to spot at night. Fairies use their magic for a variety of tasks, with a special focus on helping nature thrive (e.g., coaxing plants to grow and healing injured wildlife). They can also use their magic to disguise themselves as humans.

Attuned to nature, fairies clothe themselves in raw organic materials such as flower petals, leaves, spider webs and insect shells. Each outfit is handcrafted and unique to that fairy's interests. Requiring little sustenance, fairies feed upon nectar and sap, and cleanse their palates with dewdrops. Fairies are fond of sweet things, so fruits such as raspberries and strawberries are a special treat.

Baby fairies are a rare occurrence, created by a transformation when a human baby's laughter resonates along a butterfly's chrysalis. Once a fairy emerges from its cocoon, flight is possible as soon as its wings dry. However, first time fliers can travel only short distances before becoming exhausted, and spend a great deal of the first year sleeping, safely tucked under a large leaf, or within the closed petals of a flower, watched over by the elder fairies.

▌ Plan the Design

Explore designs and poses for your fairy children. As with human children, personalities vary from sugary sweet to shy (and sometimes pouty). Dress your fairy kin, all girls in this batch, in garb that echoes natural forms, like leafy skirts and flower crowns. For the fairy's wings, take inspiration from insects like dragonflies or butterflies.

FAIRY STATS

SPEED:	**3**
STRENGTH:	**1**
MAGIC:	**3**
CUNNING:	**2**
SPECIAL ABILITY:	**PLANT WHISPERER**

2 Draw the Body

Sketch a large circle for the head. Add horizontal and vertical guidelines to indicate a three-quarters angle as the baby fairy glances over her shoulder. Then sketch an oval for the chest, and overlap it with a large circle for her diaper-padded bottom.

3 Build Up the Head

Sketch a pair of almond-shaped eyes centered on the horizon line. Floating above, draw the eyebrows slightly lifted. In the center of the face, add a round nose. Draw the pointy ears poking out from the sides of the head. Extend the bottom of the face with a curving jawline. Then sketch the hair swept into an elegant bun, with a few bangs fanning across the forehead.

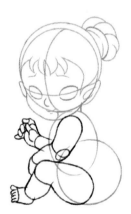

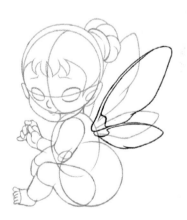

4 Sketch the Arms and Legs

Use rounded tube shapes to draw the fairy's pudgy arms and legs. Sketch the fairy's left leg outstretched to support her seated position. For the foot, draw a wedge shape, and then add toes. Position the fairy's left arm resting on her leg. Sketch an oval at the arm's midpoint to denote the elbow. Because we're looking at her left side, her right leg and arm aren't visible, except for the hand held out in a grasping position.

5 Draw the Wings

Sketch the wings in parts: a larger pair of forewings on top and a smaller pair of hindwings at the bottom. I used a different color for the far wings to help separate them. The shape of the wing depends on the type of insect. (These are inspired by a cicada.) Focus on the general wing shape, and then define the costal margin (the top edge of the wing that connects to the body). We'll add details in a later step.

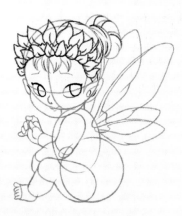

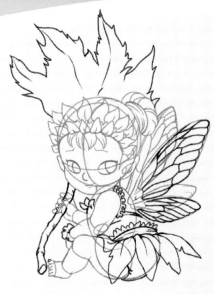

6 Draw the Facial Features

Sketch the eyes as large oval shapes, partially overlapped by dark upper eyelids. Add a little dot for a nostril, and draw the inner folds of the ear. Detail the hair following the flow of the strands. Create an adorable floral headband by layering rows of tiny flower petals.

7 Add Details

Add branching paths of veins to further develop the interior of the wings. Note that wing patterning varies by insect type, so check your references. Dress your baby fairy with a leafy skirt, a puffy cotton diaper and ruffled sleeves. Draw a large leaf splaying behind her head, with its long stem clasped in her right hand. Add nails to finish the fingers and toes.

ON GOSSAMER WINGS

Here's an alternative approach to the fairy's wings, for a more ethereal look. The shape stays relatively the same, but the edges are frayed, and the inner details lack the rigid structure of an insect's wings.

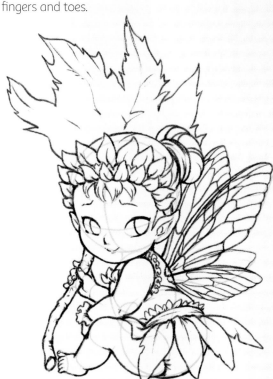

8 Refine Lines

Tighten your lines and darken around the creases. As you erase your guidelines, pay close attention to overlap (for example, the knee leading into the lower leg, or the shoulder over the face). Add some additional grooves and notches in the leaf for texture.

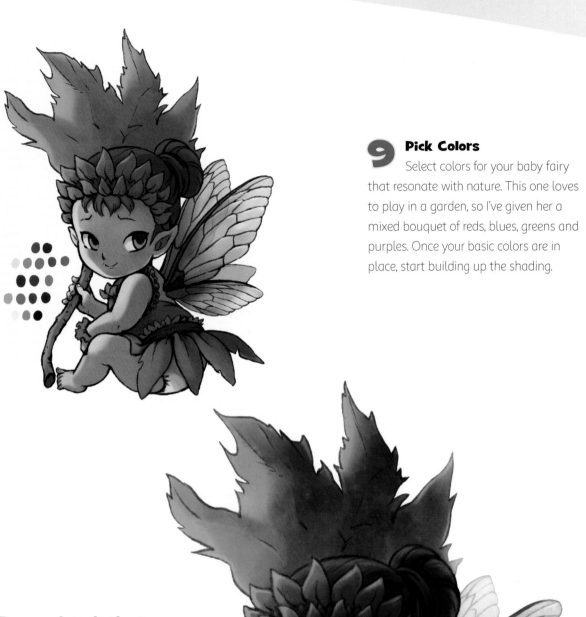

9 Pick Colors

Select colors for your baby fairy that resonate with nature. This one loves to play in a garden, so I've given her a mixed bouquet of reds, blues, greens and purples. Once your basic colors are in place, start building up the shading.

10 Finish With Shading

A large leaf shields this fairy from the sun, so cast purple shadows across her body, leaving only a hint of light along the edge of the figure. Create transparency in the wings by painting a faint silhouette of the underlying wing showing through. Use a rough brush to add texture to the leaf. Shine up those big eyes, and she's finished!

Raiju Kit

Raiju are magical thunder beasts capable of discharging powerful electric bolts from their bodies. Various types of raiju exist throughout the world, each materializing in different terrestrial forms such as wolves, dogs, cats and weasels. The beasts spend their days peacefully relaxing in the clouds. However, when clouds become charged and stormlike, raiju turn enraged and race through the skies, erratically striking trees, buildings and unfortunate creatures with electrically-charged fangs and claws.

Raiju continue in this frenzied state until most of their mass and energy are depleted and they plummet to the earth. Reduced to the size of a flea, raiju retreat into their favored nook,

an animal's belly button where warmth and moisture slowly revitalize them. Unfortunately for the unsuspecting victim, a raiju's presence causes stomach aches and discomfort as it bulks up and builds up a charge. When atmospheric conditions are right, the creature finally erupts from its belly burrow and lunges back into the sky as a fully-formed thunder beast.

Baby raiju are born in litters of up to five. Ones with a weasel-like form are called kits. Lacking the ability to control their powers, they shed electrical currents as they run and play in the clouds, making these adorable fluffy critters dangerous to handle even during periods of calm. For the first several months, their mother looks after them and teaches them how to conserve and harness their electricity.

Plan the Design

Sketch your raiju kits in lightning-quick action poses. Like electricity, they're always in motion (when they aren't sleeping). Give them adorable youthful proportions, with a big head and stubby legs. For inspiration, always refer to photos of the subject on which your creature is based—a baby weasel in this case.

RAIJU STATS	
SPEED:	**5**
STRENGTH:	**2**
MAGIC:	**4**
CUNNING:	**2**
SPECIAL ABILITY:	**LIGHTNING STRIKE**

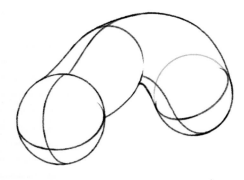

2 Draw the Body

Draw a large circle for the head. Then draw guidelines to indicate a downward head tilt. Next draw a long tube-shaped neck and attach it to another long tube shape for the body to create the elongated weasel-like noodle body. Sketch a circle with guidelines at the base of the torso for the position and tilt of the hips. Add a center line running along the body of the critter to indicate the top and bottom sides.

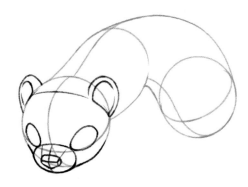

3 Build Up the Head

Draw a pair of oval eyes along the horizontal guideline. Then sketch a rounded muzzle stretching from eye to eye. At the tip, add a blocky nose with a triangular front. Sketch a guideline horizontally along the top of the head, and use it to help align a pair of rounded ears.

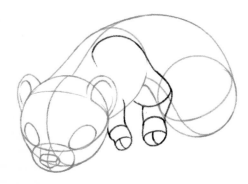

4 Sketch the Front Legs

Starting from its back, establish a connection point at the shoulder, and then use tube shapes to extend the arms beneath the body. Sketch the paws poised in a diving position. Denote bends at the elbow, wrist and finger joints. Add a line through the center of each paw—helpful for dividing them into toes later.

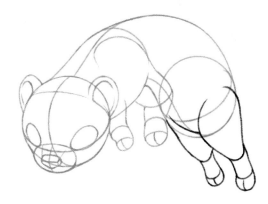

5 Sketch the Hind Legs

Draw the weasel's fully extended hind legs springing into action. Sketch the combined thigh and leg area as a drumstick-shape anchored to the guideline around the lower torso. Then use tube shapes to draw the feet. Sketch a rounded wedge shape at the ends for the toes, and add a center guideline.

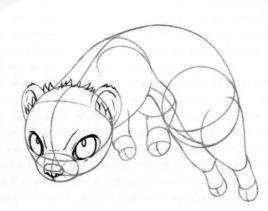

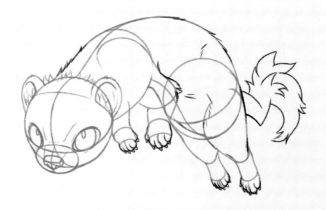

6 Draw the Facial Features

Sketch large ovals for the eyes, then add small pinpoint pupils anchored to the top for an upward gaze. Darken the upper lids and sketch a furrowed brow to give this cute kit a caustic look. Draw a crease down the front of the nose and upper lip. Add nostrils. Finally, sketch some jaggy fluff along the top of the head and inner ears.

7 Add the Tail and Details

Sketch the tail with sharp jagged angles, like a lightning bolt shooting out from behind, and then fluff out the shape with triangular bursts of fur. Use quick, broken lines to add rough fur trailing the length of raiju's back, as well as its elbow and tummy. Subdivide each forepaw into four toes and a thumb, and put five toes on each rear foot. Cap the ends with sharp claws.

8 Refine Lines

Tighten your drawing, darkening the lines as needed for impact (for example, around the eyes, the neck overlapping the body, and the curve of the back). Erase your construction lines.

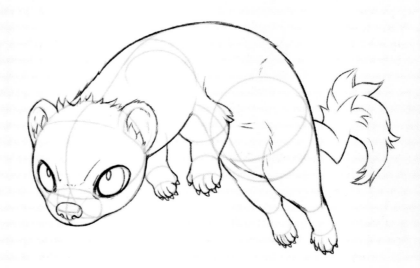

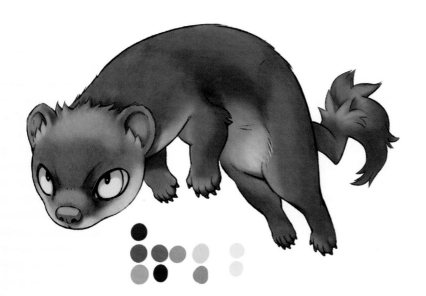

9 Pick Colors

A raiju's coat colors come in two varieties: dark like a storm cloud (purple, blue or gray), or golden and shimmering like electricity (yellow and orange). Bright pulsing plasma effects stand out best against the shadowy backdrop, so I went with dark purple for the fur. I used light blue as an accent color for the glowing eyes and matching underbelly fur, and pink for the nose and inner ears. Build up the shadows and highlights, using a rough brush to bring out the texture of the fur.

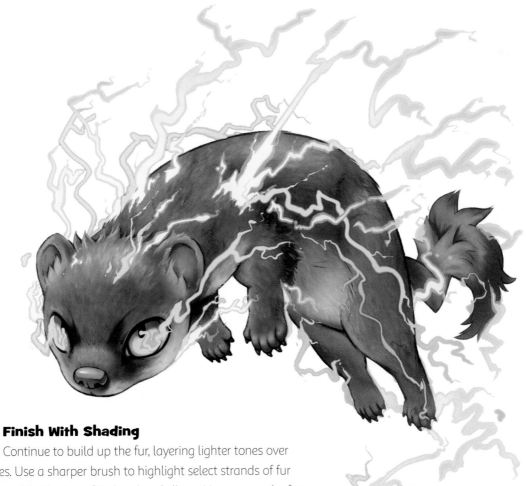

10 Finish With Shading

Continue to build up the fur, layering lighter tones over darker tones. Use a sharper brush to highlight select strands of fur and pop areas like the top of its head and elbow. Here comes the fun part: use intense blues, yellows and white to draw zigzagging bolts of electricity pulling from the raiju. Wrap the bolts around its body, varying the thickness from wide bursts to tapered tips. Enhance the effect by adding a glowing outer edge around the bolts. BZZZT!

Lil' Zaratan

Somewhere in the ocean lies an island paradise, but its location is always shifting. Any seafaring adventurers who encounter it should be wary of casting anchor and staying overnight, lest they awake to find themselves swimming in the deep blue sea.

The legendary vanishing island is no island at all, but rather the colossal shell of a species of sea turtle known as zaratans. Living for millennia, these slow-moving gentle giants dine exclusively on sea grasses and algae, between long spells of surface-bound sleep. Though tepid in temperament, their massive size presents a danger whenever they're on the move.

Because courtship happens only once every several hundred years, baby zaratan are extremely rare. The babies hatch from massive boulder-shaped eggs deposited at ancestral breeding grounds and must find their way to the ocean on their own.

The ecosystem of a zaratan's shell grows ever more complex as it ages. A hatchling may only accrue a few mossy rocks between dives, but eventually these surface slumbers last long enough for a sapling or two to grown from seeds deposited by the wind or a passing bird. Epoch-old zaratan may proudly carry an entire beachside forest and even some wildlife—at least, until the next time they submerge.

Plan the Design

Zaratan are ocean dwelling creatures, so study sea turtles for design inspiration. (For a terrestrial variety, substitute a tortoise as its basis.) Remember, we're drawing a baby, so keep the island relatively sparse and underdeveloped. Just a few palm trees and rocks will suffice.

ZARATAN STATS

SPEED:	**1**
STRENGTH:	**5**
MAGIC:	**1**
CUNNING:	**1**
SPECIAL ABILITY:	**LONGEVITY**

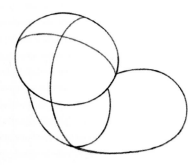

2 Draw the Body

Sketch a wide oval for the head, extending from a long tube-shaped neck. Add vertical and horizontal guidelines. Give the body an egg shape.

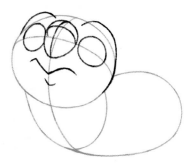

3 Build Up the Head

Draw a pair of large circles for the eyes along the horizontal guideline. Add a thick brow above the eyes. In the center of the guidelines, sketch a bulbous snout. Beneath that, draw a hooked beak.

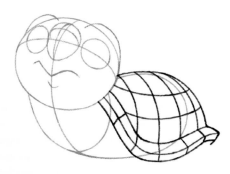

4 Sketch the Shell

Sketch the shell as a half-oval shape that encapsulates the zaratan's body. Draw the shell's outer lip bending around the neck and front of the body. Add horizontal and vertical surface lines following the curvature of the form. Note that, as with sea turtles, there isn't space underneath the shell for the zaratan to hide—not that the massive armored creature would ever need to.

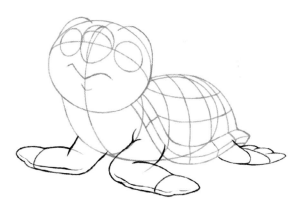

5 Sketch the Flippers

Divide the forelimbs into an upper arm and flipper segments. Draw the flippers flat and streamlined, like underwater wings. Sketch the hind flipper peeking out beneath the back of the shell. The rear flippers are very flexible and used for steering. Use surface lines to help with symmetry and shape.

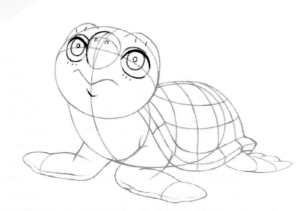

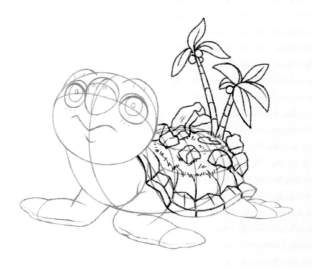

6 **Draw the Facial Features**

Sketch the eyes as ovals with small circular pupils. Give the zaratan a subdued expression by drawing the eyelids slightly lowered, and a small puckered line beneath the mouth. Add some hatched lines to the lower lid and upper brow to suggest fissures in the skin. Darken the part of the snout overlapping the right eye, and add nostrils along the guideline.

7 **Draw the Island**

To give the shell a raised spiky look, find the center point of each scute and bump them out with sharp angles. (If you prefer a smooth shell, you can leave the basic grid as is.) Add a palm tree or two, but no more—this is a juvenile. Arrange rocks, grass and perhaps even a small pond, to your liking.

8 **Refine Lines**

Do a final pass on your drawing, adding any remaining details such as the fringe on the palm leaves as well as folds and crags along the skin. Darken the underside of the shell and the upper eyelids. Further define the rocks and surrounding shell-bound undergrowth with shading and hatching. Erase your guidelines.

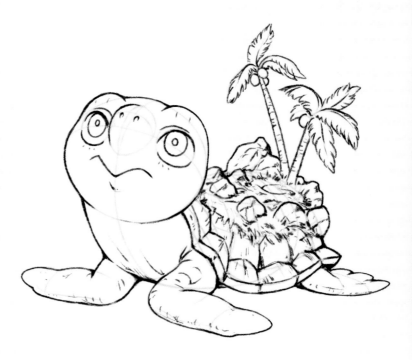

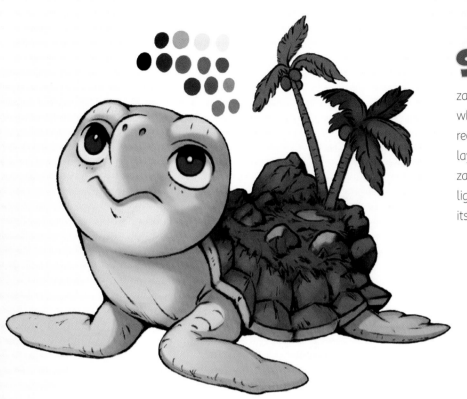

9 Pick Colors

We can pull inspiration for zaratan's colors from sea turtles, which range from yellow, olive, green, red, brown and black. Apply the first layer of shading. You can suggest the zaratan is gazing at the midmorning light by having the brightest areas on its body along the top and front.

10 Finish With Shading

Continue to build up the skin with smooth shading, gradually blending in darker tones for areas turning away from the light. Use sharp color divisions along the angular shell facets. Next decorate the skin with bold circular patches. To remind the viewer of this adorable creature's massive size, apply atmospheric perspective by misting over the backend of its shell, rocks and trees with light blue or white. Add some tiny island birds for scale.

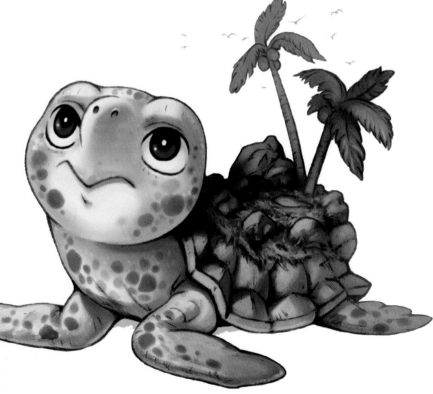

Mermaid Fry

A sea-dwelling humanoid creature with the lower half of a fish, the females are known as mermaids, while the males are called mermen. Gentle-natured and sociable, merpeople form protective underwater societies, living in structures made of coral, where they work and play together. They communicate among themselves and other aquatic creatures through songs. Merpeople are equipped with a set of both gills and lungs, enabling them to breathe underwater and above. However, they are vulnerable on land due to their lack of mobility and can dry out if they remain out of water for too long. A popular mer pastime is human-watching, but care must be taken to not be seen for fear of being caught.

Merbabies, also called fry, keep close to their mothers and swim by riding her slipstream—the wake created by the thrust of her fin—or clinging to her long, undulating hair. Gradually they learn to control and coordinate their arms, fins and tail to swim without assistance. It takes about a year for a fry to become a confident swimmer, capable of going on solo excursions. Highly creative, they enjoy crafting shells, seaweed and other found curiosities into clothing and accessories—a lifelong hobby.

Plan the Design

Explore designs for your mermaid fry as she explores her underwater surroundings. Adorn her with loose fitting garments and pretty shells. Try a variety of flowing hairstyles from curls to long and wavy. A starfish friend makes for a fun accessory.

MERMAID STATS

SPEED:	**4**
STRENGTH:	**1**
MAGIC:	**1**
CUNNING:	**2**
SPECIAL ABILITY:	**CHARISMATIC**

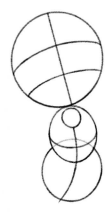

2 Draw the Body

Sketch a large circle for the head. Indicate a front-facing position with a straight line through the center, and add a pair of horizontal guidelines for the forehead and eyes. Draw the rib cage as an egglike oval shape. Sketch a guideline across the chest and a circle for the base of the neck. Next draw a larger circle underneath for the lower torso. Draw a line through the center of the body.

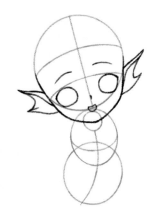

3 Build Up the Head

Extend the bottom of the face by drawing the jawline with rounded cheeks. Sketch a pair of large, almond-shaped eyes, upper lids aligned with the horizontal guideline. Floating above, sketch her gently curving eyebrows. Halfway down the lower face, draw a petite nose indicated by a simple line. Then halfway between the nose and chin, add a tiny smile. Finally, draw a pair of pointed, finlike ears pulling from the sides of the head.

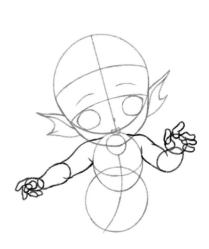

4 Sketch the Arms

Anchor the shoulders to the rib cage, drawing a crease where the arms and chest meet. Then draw the arms as long undulating tubes. Make the left arm slightly larger than the right, as it reaches toward us with a curious gesture. Sketch small circles for the palms, and add little fingers splayed gracefully.

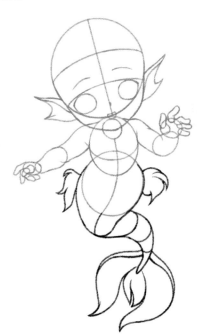

5 Sketch the Tail

Extend the center line of the body. Then draw the tail as a long curving tube, wide around the hips and tapered to a thin point. Use surface lines to visualize the shape. Add a pair of puffy pelvic fins along the sides. Broaden the end of the tail into a swishy, forked fin.

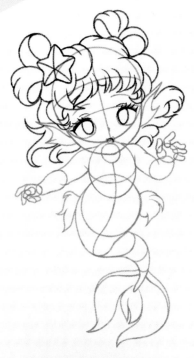

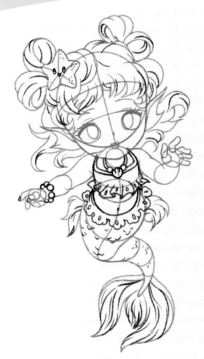

7 Add Details

Dress your mer fry with a cute pleated halter top, shell necklace and pearl bracelet. Sketch a frilled skirt around the waist, cleanly dividing her human half from her fish tail. Detail the hair and fins with additional crease lines. Add fingernails to the visible topsides of the fingertips. Draw U-shaped scales along the length of the tail. Give the friendly starfish a smiling face and some speckled bumps for texture.

6 Draw the Facial Features

Draw the eyes as ovals, then darken and extend the upper lashes. Add a tongue inside the mouth. Sketch the hair as free flowing tresses, bounced by the ocean currents. Loop the longer locks into twin bunches on the top of her head, out of the way while she swims and plays. To draw her hair accessory, sketch a vertical line intersected by two crisscrossing lines—guides for the star's rounded tips.

8 Refine Lines

Do a final pass on your drawing, and erase your guidelines. Darken around areas including the eyelids, starfish, under the head and around the waistline. Add some bubbles of irregular shapes and sizes, cumulating into a large, heart-shaped air pocket. How sweet!

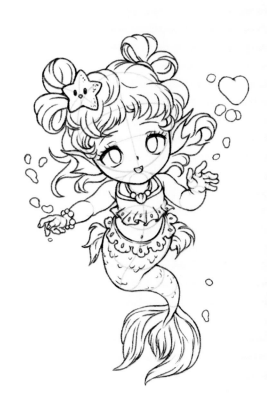

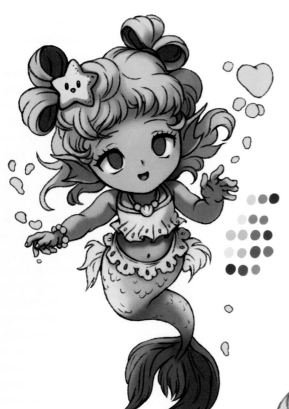

9 Pick Colors

Select colors for the mermaid's hair, skin and scales that blend in a pleasing harmony. Teal hair and silvery-purple skin look appropriately oceanic and set her apart from those terrestrial humans. Add basic shadow tones along the underside of the body.

10 Finish With Shading

Continue building up the shadows' soft shading. Add a golden glow to her hair from the sun above. Give the tail an iridescent shimmer by blending multiple colors together. (I used aqua-green, yellow and purple.) Then blend blue-gray into the most trailing portions of the tail to simulate diminishing detail in the light-absorbing ocean waters. Add highlights to her eyes, bubbles, jewelry and scales.

Quetzalcoatl Hatchling

Resplendent in green, red and blue plumage, a quetzalcoatl is a massive winged serpent most often found in warm tropical regions. It flits through the skies in wavy patterns, like a snake slithering through the grass, watching over human villages below. A benevolent guardian, it has the power to command the wind and rain to bring good harvest to those in need. In return, villagers perform elaborate dance rituals and erect large pyramid-shaped temples to honor their feathered serpent supporter. Highly intelligent, a quetzalcoatl can communicate through a third eye in the middle of its forehead, and will on occasion use it to "speak" to humans to offer guidance and knowledge.

When a female quetzalcoatl is ready to lay eggs (usually one to three at a time), she builds a nest within the refuge of her temple. Hatchlings are cared for by both parents. Young quetzalcoatl remain in their birth temple while they learn the wisdom of their elders. When they have mastered "becoming one with the wind," a process that can take as many as twenty years, they depart to adopt a village of their own.

Plan the Design

Sketch airborne poses full of twisting curves for your quetzalcoatl hatchling, a masterful flier even at a young age. Some versions of quetzalcoatl depict the feathered serpent as wingless, using instead magical powers to glide through the air. However, I felt wings enhanced its strong, majestic silhouette. Embellish the serpent with decorative feathers, scale patterning and a ceremonial tail band.

QUETZALCOATL STATS

SPEED:	**4**
STRENGTH:	**2**
MAGIC:	**5**
CUNNING:	**3**
SPECIAL ABILITY:	**RAIN MAKER**

2 Draw the Body

The quetzalcoatl has an elongated head shape, so start by sketching an egg. Add horizontal and vertical guidelines wrapping around the surface. Pull a pair of long, curving lines from the base to form the beginning of the creature's long snakelike body. Then draw an inner pair of lines to denote the underbelly.

3 Build Up the Head

Draw a short, boxy snout extending from the center guideline of the head. Align the horizontal edges (chin, nose and eye lines). Pull the sides of the snout back into the egg shape to form the brow and jawlines. Centered between them, sketch a large round eye. Finally, draw a long mouth line.

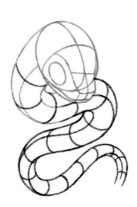

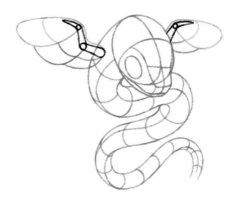

4 Sketch the Body

Continue the serpentine path established in Step 2 by sketching a long, tapered tube shape for the baby quetzalcoatl's body. Make the body twist and turn several times on its journey to the tail tip. Use surface lines to visualize the form. Continue the inner belly line.

5 Sketch the Wings

Draw the wing bones as simple tube shapes; similar to human arm bones, there are joints at the elbow and wrist. Divide each wing into primary (denoted in pink) secondary (purple) and tertiary (green) feather sections. Add a shorter layer of covert underwing feathers above them.

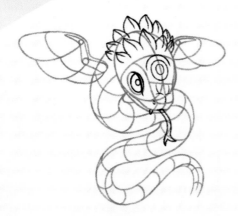

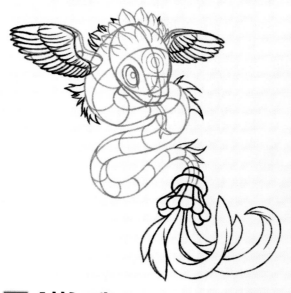

6 Draw the Facial Features

Sketch an oval-shaped eye with a round pupil. Draw the upper lid slightly lowered. Add ridges to the top of the snout. Then draw a nostril, fang and forked tongue. Finally, adorn the head with two rows of short feathers and a mid-forehead circular eye pattern representing the serpent's mysterious third eye.

7 Add Details

Working from outside in, draw the individual feathers. Pay careful attention to overlap. When viewing the wing from the underside, primaries overlap secondaries and axillaries. Then draw a shorter layer of covert feathers and fluffy down on top. Add uneven fringe along the creature's head and body. At the base of the tail, draw long decorative feathers flaring out from a ceremonial band.

8 Refine Lines

Carefully go over your lines, darkening creases where the body folds and twists. Also darken the lines around the eyes, tongue, and under the head to help bring attention to those areas and create depth. Draw scales along quetzalcoatl's belly, following the curvature of the form. Sketch some hatched lines on the body and along the edges of feathers for added texture. Echo the design of the third eye on the tail band. Erase your guidelines.

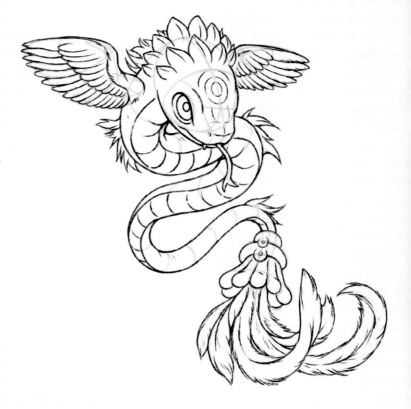

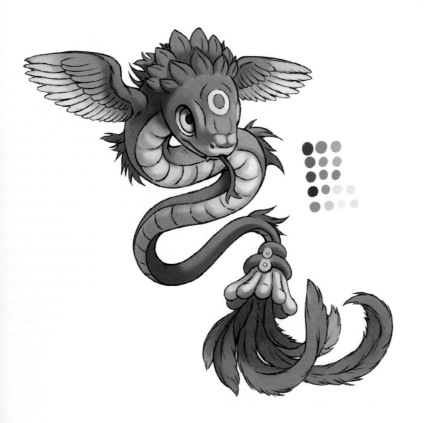

9 Pick Colors

Select bold and bright colors befitting a tropical bird for quetzalcoatl's plumage. I used a bright green for the body, with red, blue and yellow as accents. Fill in the first layer of shadows to indicate lighting from the sky above.

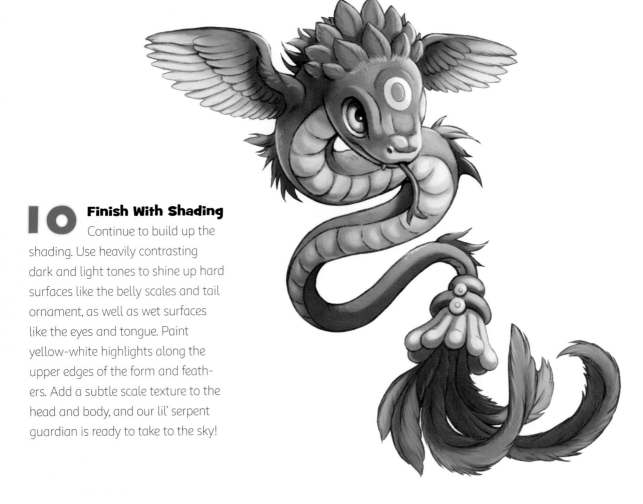

10 Finish With Shading

Continue to build up the shading. Use heavily contrasting dark and light tones to shine up hard surfaces like the belly scales and tail ornament, as well as wet surfaces like the eyes and tongue. Paint yellow-white highlights along the upper edges of the form and feathers. Add a subtle scale texture to the head and body, and our lil' serpent guardian is ready to take to the sky!

Satyr Kid

Also known as fauns, satyrs are half-human, half-goat, carefree and fun-loving woodland creatures. They have the face, upper body and arms of a human, but walk on fuzzy cloven-hooved legs. Other goatlike features include horns, a tail and long pointed ears. Though slightly sunken by their ungulate stance, satyrs still stand around average human height, at 5 to 6 feet (1.5 to 2m). Satyrs rarely wear clothes, instead preferring to go au naturel, with their dense fur providing plenty of warmth and padding to their lower extremities.

For a satyr, life is one continuous party. One celebration flows into the next while they partake in food and drink, dance, music and merriment. Natural musicians, satyrs are especially skilled with instruments like the pan flute and pipes, which they effortlessly master. Utterly devoted to diversions, any strenuous labor is met with derision. It's perhaps for this reason they make their homes out of preexisting structures such as tree cavities or abandoned bear dens. Some even prefer to sleep on a bed of leaves, out in the open, beneath a canopy of trees.

Young satyrs, called kids, are typically left on their own for unstructured play. The kids spend their time frolicking through the forest, playing games, climbing and sparring with some good-natured headbutting. They are, however, expected to help with gathering fruits and berries, and be present at all faun festivities.

Plan the Design

Although all satyrs are gregarious by nature, individual personalities vary from confident and jubilant to timid and cautious. Explore your kid's personality through their expression and pose. Satyr are quite nimble on their goat legs, even the younglings, so be sure to put some spring in its step.

SATYR STATS

SPEED:	3
STRENGTH:	2
MAGIC:	1
CUNNING:	3
SPECIAL ABILITY:	**NATURAL ENTERTAINER**

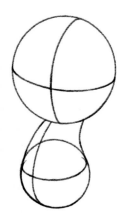

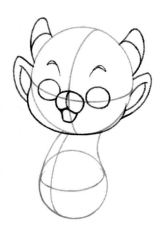

2 Draw the Body

Draw a large circle for the head, and add guidelines. For the body, sketch a bottom-heavy pear shape, using a circle for the lower half. Sketch a line down the center of the chest (turning to his right), and a horizontal line along the waist.

3 Build Up the Head

Extend the sides of the face with adorably round cheeks. Draw a pair of circles along the horizontal guideline for the eyes. Centered between them, draw a bulbous muzzle with the lower jaw open in a sweet smile. Draw the eyebrows gently curving toward the center. Add a pair of pointy goat ears and budding horns.

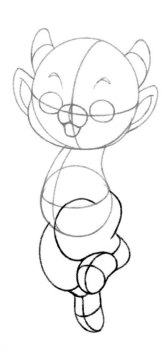

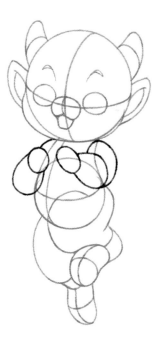

4 Sketch the Goat Legs

Sketch the satyr kid's right leg extended with toes pointed down as it bounces off the ground. Compress the left leg, pushing the foot into the knee region. Draw the haunches large and rounded to account for the dense fur. Divide the lower legs into ankle, foot and hoof sections. Sketch a line through the center to cleave the hoof into two toes.

5 Sketch the Arms

Draw the shoulders plump and round, with the arms lifted to their chest, exhibiting a blend of shyness and playfulness. Draw the hands as simple circles for now—we'll add the fingers later.

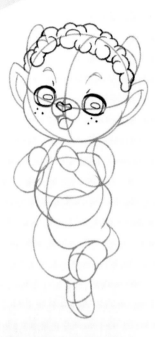

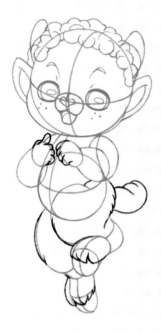

7 Add Details

Draw the fingers curled around the base of the hand with the pointer finger extended on the right. Sketch some fur to fluff out his legs and cover the tops of his hooves. Add a swishy tail with soft curves.

6 Draw the Facial Features

Detail the eyes. Satyrs have rectangular pupils, like goats, which give them a unique look (and excellent peripheral vision). A couple of freckles on the cheeks add to his cuteness. Draw a heart-shaped nose and a tongue. For curly hair, use overlapping semicircles to build up the volume.

8 Refine Lines

Tighten your lines. Remove the lines around the muzzle leaving only the mouth and lips. Add some ridges to the horns to give them a bumpy texture. Draw a belly button in the middle of his tummy (where the waistline meets the centerline). Erase the rest of your guidelines.

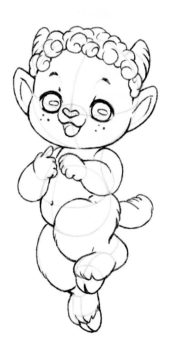

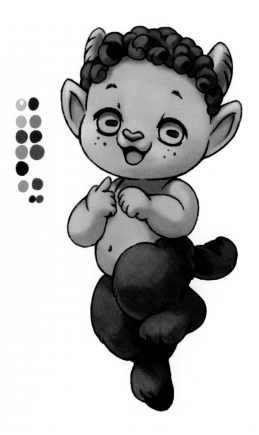

9 Pick Colors

Satyrs resemble humans in terms of skin and hair color. Match their fur color with their hair. If desired, pick an accent color for striking eyes. Horns and hooves range from tan to black. Once the base colors are in place, start to block in the shadow tones.

10 Finish With Shading

Continue to build up the shading. To create a soft, subtle fur texture on the lower body, use brisk strokes, layering lighter tones over darker tones. Apply strong highlights to the horns and eyes to make them shine. To bring out detail of his hair, brush a lighter color following the direction of the curls. As a final effect, add highlights along the underside of his hooves, knees, tummy, arms and head (caused by light bouncing from the ground). Add a cast shadow beneath him to emphasize his lively leap.

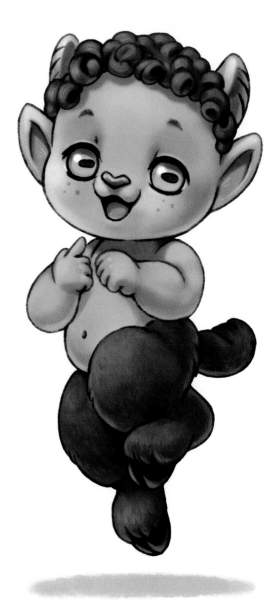

Troll Tyke

Trolls are hostile, ugly and unkempt humanoid creatures. They have warty and gnarled skin, and coarse, wiry hair. Most trolls stand around 7 feet (2.25m), though some species can grow to mountainous 50-foot (16.5m) monstrosities! Although trolls are slow-witted, they are quick to react with a boulder toss or swing of an oversized club or fist. With large appetites befitting their towering frames, they'll gleefully thump (and eat) anything that moves, from worms to bears.

Trolls roam in rocky, mountainous regions in small groups, sheltering in caves or forests. The alpha troll, the strongest in its clan, takes the lead on hunting parties and raids on human villages. Although few things frighten them, trolls will flee from lightning, and they dislike the sound of bells. Some trolls find sunlight to be uncomfortable or even hazardous, with instances of trolls turning to stone from sun exposure. These sun-averse trolls prefer to hide under bridges or in caves during the day.

There are usually at least a few troll children running around in a group. These tough tykes act like little adults, imitating their unruly elders in all their various exertions of violence.

Plan the Design

Though they lack basic hygiene, young trolls, with their large heads and messy hair, have a certain cuteness to them. Look for ways to convey both stupidity and savageness in the expression and pose. Give the little troll sinister beady eyes and a comically large nose. A hunk of meat makes a great prop—handy as a snack or a weapon.

TROLL STATS

SPEED:	**3**
STRENGTH:	**4**
MAGIC:	**1**
CUNNING:	**1**
SPECIAL ABILITY:	**BRUTE STRENGTH**

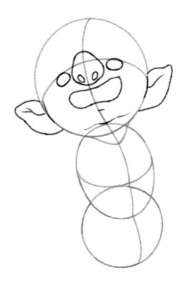

2 Draw the Body

Draw a large circle for the head. Add guidelines to indicate the head tilting up. Sketch the chest using an oval shape, and add a horizontal line for the pecs. Beneath that, sketch a circle for the pelvis. Connect the head to the body with a thick neck. Then draw a centerline down the body, following the curvature of the form.

3 Build Up the Head

Sketch the eyes as small ovals, positioned on the horizontal guideline. Centered between them, draw the upturned underside of a large nose with flaring nostrils. Stretch the mouth open in a wide wicked smile, and then draw the lower jaw and chin. Sketch the ears long and pointed.

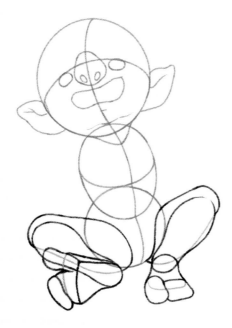

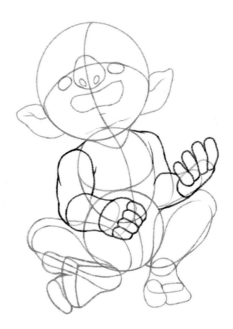

4 Sketch the Legs

Draw the troll's legs spread in a relaxed, sitting position. Sketch the thighs as lanky tubes. Next draw the lower legs with plump calves, tapering around the ankles. Draw the feet as large rounded wedge shapes. Add a big toe on each foot, and then draw the smaller toes as a cluster.

5 Sketch the Arms

Start by roughing in the arms as thick tube shapes. Then refine the shape to emphasize the musculature—even the young trolls have well-developed physiques. Sketch the hands as simple circles, positioned as if holding a club or leg of meat. Then add fingers, one hand gripping around an imaginary handle while the other supports the top.

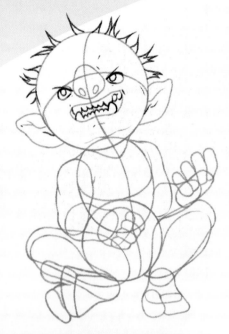

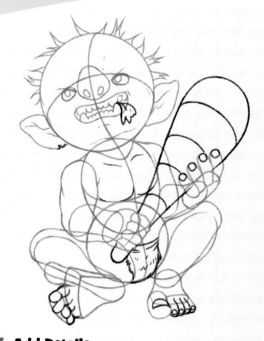

6 Draw the Facial Features

Sketch small eyes framed by brows lowered in malicious intent. Draw two rows of teeth with prominent canines and an overbite. You don't need to make the teeth (or anything on a troll) perfectly straight; irregularities will reinforce the troll's beastly look. Sketch the hair in erratic, thin angular patches. Add some crease lines on the face and ears.

7 Add Details

Define the shape of the chest and indicate the clavicle bone. Divide each foot into individual toes. Add nails to toes and fingers (where the topside is visible). Small imperfections such as a notched earlobe help add character. Draw a meaty drumstick in the troll's hands—weapon, dinner ... or both? A chunk of flesh in the troll's mouth provides a clue. Finally, clothe your troll in animal fur.

8 Refine Lines

Darken your lines and erase any guidelines. Carve a chunk of meat out of the bird leg—om nom nom! Add creases between fingers and toes, and a few cracks in the nails. (These guys play rough.)

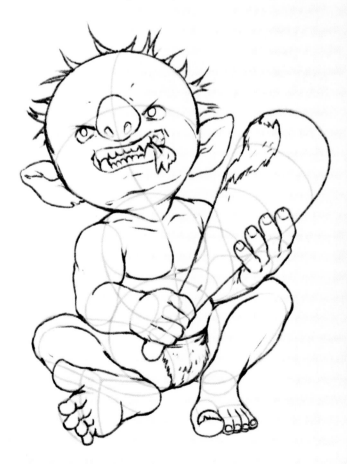

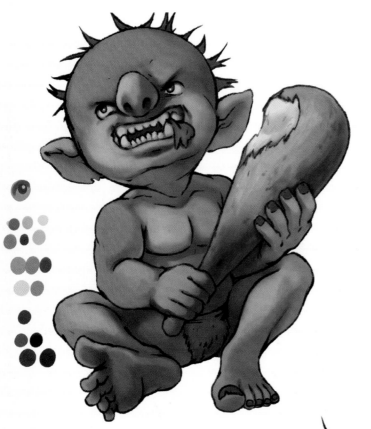

9 Pick Colors

Troll colors vary by region and species—some can even be quite colorful, with brightly tinted hair. Rosy noses are a common trait. I chose a putrid yellow-green for the skin, with charcoal gray hair and nails, and grimy yellow teeth. Build up the basic shadow tones.

10 Finish With Shading

Deepen the shadows in areas such as the neck, nostrils, inner ear, creases and so on. Dapple green and yellow color flecks across the skin to create a bumpy, uneven texture. Don't go too heavy with the highlights, except for the nails and eyes—we want the troll to have a rough, grungy finish. Bounce some eerie purple tones on the underside of the hands, legs, club and face. Then add a cast shadow on the ground to fully render our repulsive rascal.

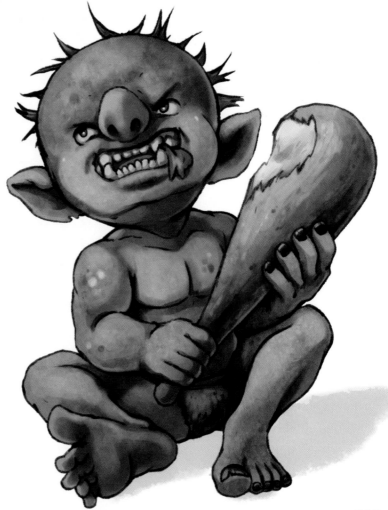

Unicorn Foal

The unicorn is a magical equine creature known for the spiral horn protruding from its head. Elusive and shy, unicorns dwell within woodlands. They are considered untamable and difficult to capture, but have been known to appear before, and even bond with, pure-hearted individuals. The unicorn's horn possesses magical powers, granting the horn's wielder abilities such as healing, poison purification and possibly even immortality. For this reason, the horn is highly sought after by those who want to claim its powers for themselves.

Unicorns seek the protection of an enchanted glade to give birth, usually to a single foal. Newborn foals are nearly identical to baby horses, except for a small horn nub and an elongated neck and legs. Although initially unsteady on its hooves, a unicorn foal can trot and gallop within a matter of hours. Their horn grows as they age, eventually reaching a length of up to 3 feet (1m).

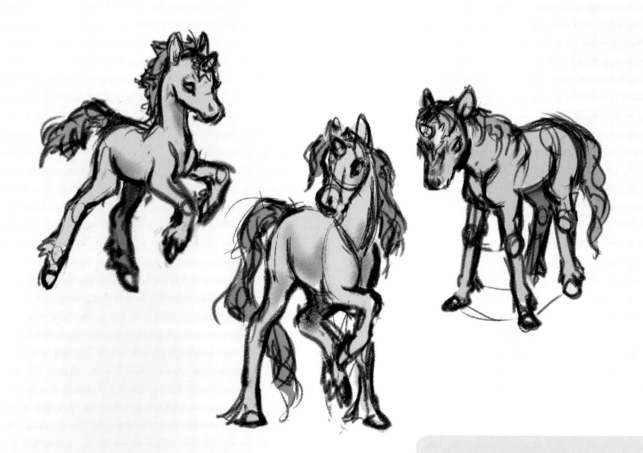

Plan the Design

Sketch unicorn foals in agile or dignified poses, with gentle eyes. Note the proportions: foals have long legs in relation to their body. A short mane and tail present a youthful appearance, but you may prefer the elegance of longer locks. Don't forget their signature helical horn.

UNICORN STATS

SPEED:	4
STRENGTH:	2
MAGIC:	4
CUNNING:	4
SPECIAL ABILITY:	**HEALING MAGIC**

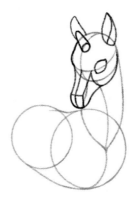

2 Draw the Body

Sketch a small circle for the head, with guidelines for facial features. Draw a long cylindrical neck plunging into a larger circle for the chest. Sketch a curving center line to show the foal turning its head to look to the side. Finally, draw a distant circle for the hindquarters, and connect it to the chest with lines along the top and bottom.

3 Build Up the Head

Sketch an almond-shaped eye along the horizontal guideline. Bump out the brow on the right side. Extend the long, narrow muzzle from the center of the face. Sketch the unicorn's cheek curving around the side of the face, and connecting with the bridge of the nose. Extend a small rounded horn from its forehead. Finally, attach the ears to the top of the head, and add a curved line to indicate the edge of the inner ear.

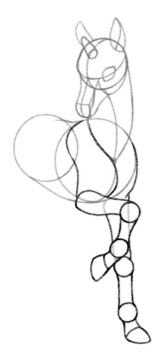

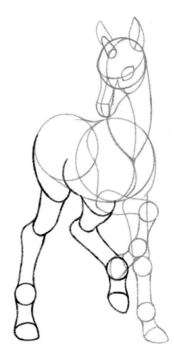

4 Sketch the Forelegs

With all those knobs and bends, equine legs can be a bit bewildering. When drawing any complicated object, it helps to simplify into basic shapes. Wrap the shoulder mass around the base of the neck; the forelegs attach to the sides of the chest. Starting from the elbows, draw the rest of the legs as long, narrow tube shapes, with spheres for the joints. Cap the ends with sturdy hooves.

5 Sketch the Hind Legs

Sketch the upper legs from pelvis to the end of the femur/knee as a solid mass, nestled behind the belly. Draw a cylinder shape to extend the legs down to the ankle joint (sometimes mistaken as a "backwards knee"). Finish the foot region of the legs with another series of tubes and spheres, ending with the hooves.

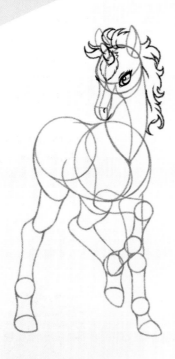

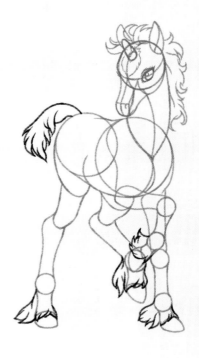

6 Draw the Facial Features

Draw a large eye with a gently lowered lid and heavy eyelashes; don't forget the lashes peeking out behind the brow of the right eye. Sketch the nostril as a half circle. Draw a small line for the mouth beneath it. Draw a series of spiraling lines to create the pattern on the horn, and add a patch of fur around the base. Finally, sketch the mane with brisk curving lines for a wild, untamed look.

7 Add Hair

Sketch the tail with a dignified high arch, and divide the hair into segments using brisk curving lines, as you did for the mane. Add long hair, called feathering, around the bottom of the legs and hooves to protect it from thorns during treks through forest undergrowth.

8 Refine Lines

Go over your lines, tapering from thick to thin for a soft, elegant quality. Bump out the ankle bone and add subtle suggestions of equine anatomy by emphasizing creases around the joints and furrows where tensed tendons ripple the skin. Erase your guidelines.

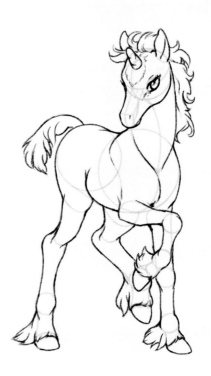

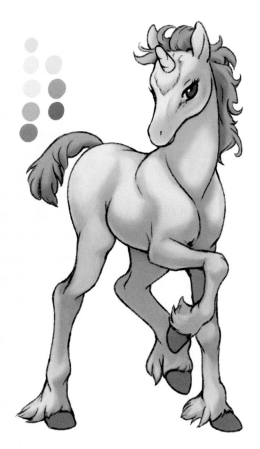

9 Pick Colors

Unicorns are born with a light gray or silver coat that lightens to a shimmery pearl white with age. Their mane and tail colors range from white and silver to a dazzling rainbow cascade of primary tones. In this case, I went with lavender locks to contrast the otherwise uniformly colored coat. Gold and silver are common horn and hoof colors. I added a touch of peach on the nose and inner ears. For the shadow tone, rather than using a bland gray, introduce a hint of color such as purple for a more vivid sheen.

10 Finish With Shading

With the light shining from above, place the deepest shadows on the inside of the legs, under the head and within creases. As you build up the shading, keep the overall tone light and airy. Sharply divide the base and shadow colors on the horn and hooves to make them shine. Finally, paint a glowing circle and sparkles around the horn to give it a magical aura.

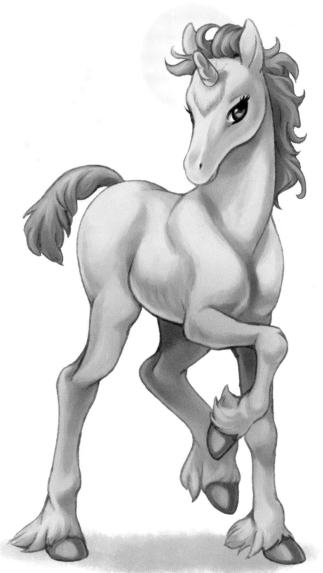

Shishi Cub

Shishi are guardian lions, magically brought to life from stone, similar to gargoyles. Shishi are typically found in familial pairs, guarding the entrance to a shrine or temple from evil spirits. Although they may look frightening, they are gentle-natured and noble, allowing the virtuous to pass without harm. The pair sit in mirrored opposition: the male is open mouthed, his right paw resting on an ornate temari (embroidered ball), while the female's mouth is closed and her left paw encircles their tiny cub. From the pair's open and closed mouths, they hum two notes that combine to create the sacred "Om" sound, symbolizing life and death, the beginning and the end.

Shishi normally give birth to a single cub. The mother takes full responsibility for the cub, with the pair forming a deep bond and rarely separating during the first year. She takes great pride in the care of her cub, meeting its needs and lovingly grooming its curly mane and fur. However, true to her nature as a guardian beastie, she can be overbearing, often pinning her tiny cub under paw to defend it from harm and keep it from straying. Once the cub reaches maturity, it eagerly departs to find independence, a mate and a sacred building to protect.

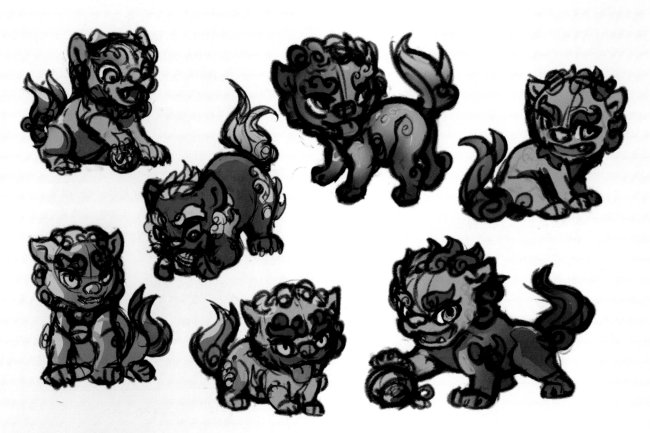

Plan the Design

Sketch your shishi cub with large eyes, a curly mane, swirling locks of fur and an upright, bushy tail. Choose active, playful puppylike poses. A ball makes a great prop.

SHISHI STATS

SPEED:	**3**
STRENGTH:	**4**
MAGIC:	**1**
CUNNING:	**1**
SPECIAL ABILITY:	**REPEL EVIL**

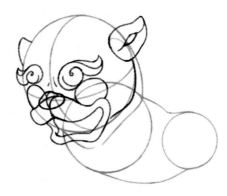

2 Draw the Body

Sketch a large circle for the head, with guidelines for positioning and direction of facial features. Beneath that, sketch another large circle for the chest. Connect it to the head with a thick neck. Next draw a smaller circle for the rear. Finish the torso shape with a muscular hump on top, and a bulging belly line dipping below.

3 Build Up the Head

Sketch a pair of large circular eyes along the horizontal guideline. Draw the wide, open mouthed muzzle filling the bottom half of the head, fit snugly around the eyes, with the cheek overlapping. In the center, add a chocolate-chip-shaped nose. Draw thick brows with a wild swirl shape, one raised and the other lowered, to give the cub a wry expression. Finally, draw a pair of triangular ears positioned at the top of the head.

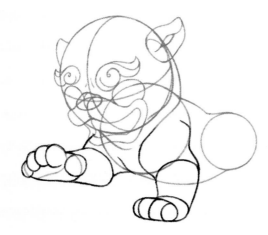

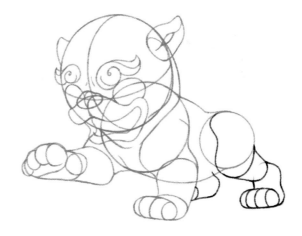

4 Sketch the Forelegs

Sketch the forelegs with sturdy proportions capable of carrying our hefty cub. Draw the muscular shoulders wrapping around the base of the neck. Sketch the left foreleg planting into the ground. Then sketch the right foreleg, reaching out for a ball. Be sure to indicate the bends at the elbow, wrist and paw.

5 Sketch the Hind Legs

Lightly indicate the pelvic bone, and then pull the shape into a rounded knee around the belly line. Next sketch the lower leg as a cone shape. Attach a foot with raised heel and toes pressing into the ground. Don't forget to draw the far leg.

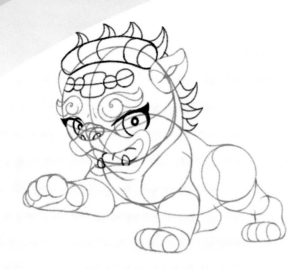

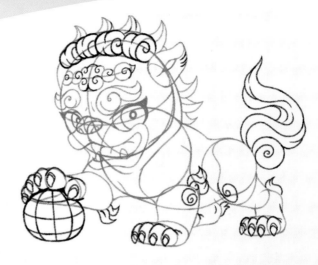

6 Draw the Facial Features

Draw the eyes with circular pupils, like a lion's. Darken the upper lids and add thick, curling eyelashes in the outer upper corners. Inside the mouth, sketch two rounded fangs and the indication of the tongue. Give the nose a pair of flaring nostrils. For the head crest, start simple with squares and circles, planning out position and symmetry for the complex patterns. Finally, sculpt the front of the mane using a long cylinder shape, and divide it into four sections. Then add triangular tips in the back.

7 Add Details

Time to add the shishi's signature swirls to its mane, crest, elbows, ankles and knees. Then sketch a tail with an S-curve, coiling at the base. Add some decorative lines on the tips of the ears. Draw the individual toes, and add claws with a defined cuticle. Finally, sketch a circular ball squishing into the ground from the weight of the left paw. Add guidelines.

8 Refine Lines

Go over your drawing, darkening around creases such as the hairline, inner mouth and nostrils, the base of the neck, between the toes, and the belly. Following the curvature of the ball, carefully pencil a geometric pattern; refer to photos of temari for inspiration and you will find many ornate designs from simple to complex. Erase your guidelines.

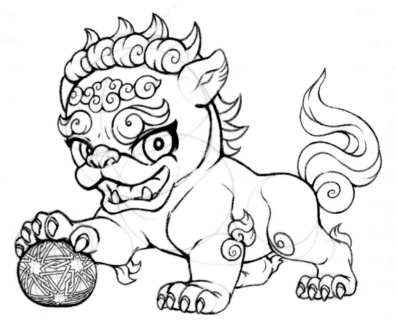

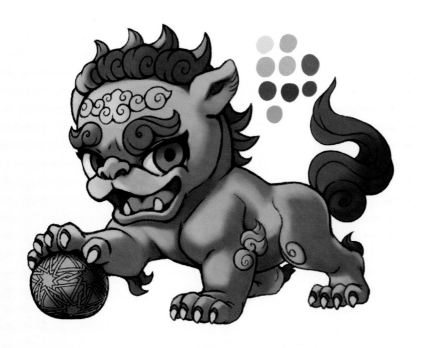

9 Pick Colors

Shishi are traditionally formed from stone or bronze, and often take on the color of their materials. But they can also appear in an array of other painted colors, especially red, green, gold and blue. Place your base colors and do a first shading pass to indicate a strong sunny light source coming from the front left side.

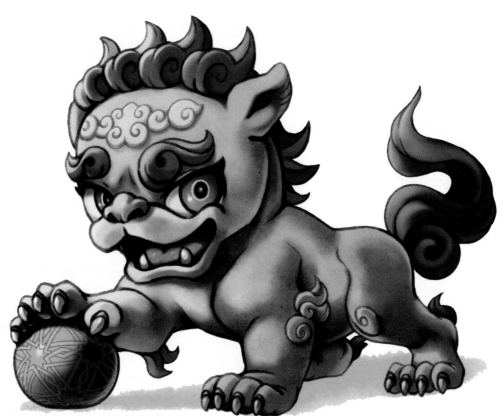

10 Finish With Shading

Brush a yellow glow along the shishi's right side. Using darker tones, dab a sponge or use flecks from a rigid brush to suggest a stone texture to the skin. Stipple additional specks of light and dark to strengthen the look. Add bright highlights to the eyes, teeth, ball and claws for a glossy shine, and our playful temple guardian-in-training is complete!

Wyvern Whelp

A wyvern is a scaly, reptilian creature with two legs, wings in place of arms and a barbed tail. Highly territorial and aggressive, they are quick to strike with teeth and claws. Although similar in appearance to their four-legged dragon cousins, wyverns are smaller, far less intelligent, and do not hoard treasure or breathe fire. They prefer to roost in lofty or remote locales, like the tops of abandoned castles, secluded caverns or along mountainsides, hidden among boulders and craggy debris.

A wyvern lays her eggs, typically three to five in a clutch, in a safe, dark place, and will vigilantly watch over them. When a wyvern baby is ready to emerge, it tears through the soft, leathery shell using small but sharp fangs. Once all the whelps hatch, the mother departs, fulfilling her role in their development. From there, it's survival of the fittest as the hatchlings compete for food and shelter while struggling through their first flight efforts. Life for a baby wyvern is tough, but those that make it through the early weeks eventually become acrobatic flyers and masterful hunters.

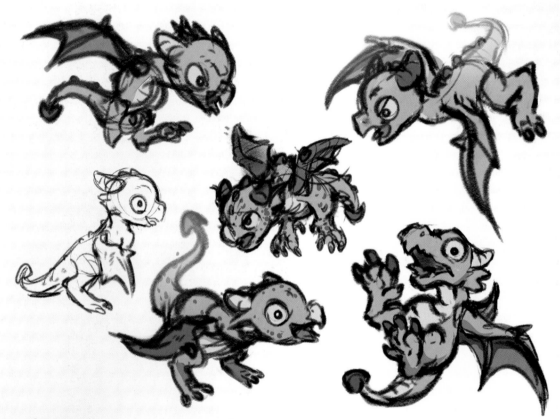

Plan the Design

Lacking the wit of its dragon-kin, sketch your wyvern whelp wide-eyed and clueless as it tumbles and bumbles through its early attempts to fly. Give it large claws and a beaklike muzzle to defend itself. In contrast to the tail of an adult wyvern, a whelp's tail is soft and spade-shaped, but will slowly harden into a deadly barb as it matures.

WYVERN STATS

SPEED:	**5**
STRENGTH:	**3**
MAGIC:	**1**
CUNNING:	**1**
SPECIAL ABILITY:	**AERIAL ACROBATICS**

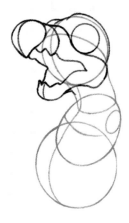

2 Draw the Body

Draw a circle for the head, with guidelines indicating an upward gaze. Then sketch a long tube neck connected to an egg-shaped chest. Finally, sketch a large circle for the lower torso, giving the whelp a bottom-heavy appearance.

3 Build Up the Head

Draw a large circular eye along the horizontal guideline. Bump the brows above the top of the head, partially encircling the eyes. Extend a beaklike muzzle from the center of the face with jagged jaws stretching open with uncertainty. Use surface lines to break the beak into manageable sections and visualize its volume. Wrap the lower mandible around the base of the head.

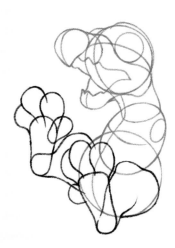

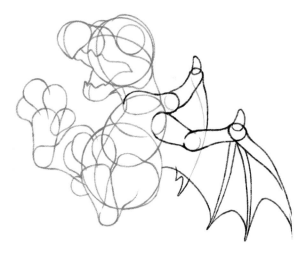

4 Sketch the Legs

Draw the legs awkwardly flailing as the whelp struggles to right itself in the air. Attach each leg to the hip with a rounded, meaty thigh. Define the knees, then draw the long, wedge-shaped feet. Add three bulbous toes at the end and a fourth on the inside of each foot.

5 Sketch the Wings

Sketch the wyvern's wing arms divided into three segments—one for the upper arm, the lower arm and the hand. Draw two spiked "finger" projections extending from the hand segment. Sketch an upside-down U-shape to connect the hand segment to the next spike. Continue this arching line to the following spike and then into the back of the wyvern to complete the wing shape. Finish the wings with a stumpy thumb hook on the top of each hand, useful for snagging perches and prey.

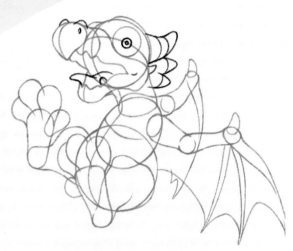

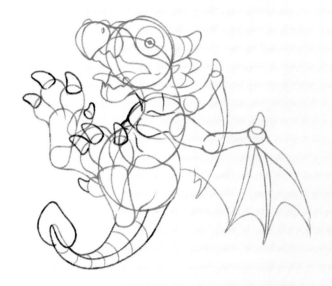

6 Draw the Facial Features

Draw a small circular eye and pupil centered within the sclera (eye whites) to complete the wyvern's bewildered expression. Sketch a large horn extending from the back of the head and two additional outgrowths beneath it. Add another spike protruding from the corner of the jaw. Draw a pair of nostrils at the tip of the muzzle and a tongue poking out between tiny fangs.

7 Add the Tail and Details

Sketch the tail, curving down and around so that the underside is visible. Use surface lines to express the curvature. Add a spade shape to the end of the tail, overlapping the tip. Define the wyvern's rib cage and musculature of the chest. Draw claws at the end of each toe.

8 Refine Lines

Almost there! Go over your drawing, darkening around creases and removing any unnecessary construction lines. Use the surface lines on the tail as a guide for drawing the scutes (bony scales). Add creasing in the wing membrane. Add some hatched lines to the back of the wing for texture.

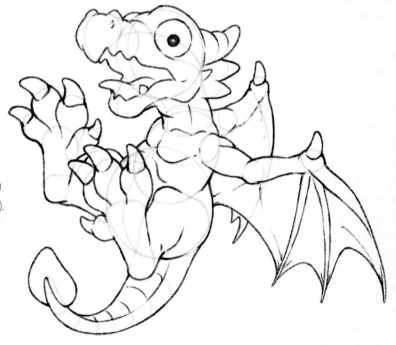

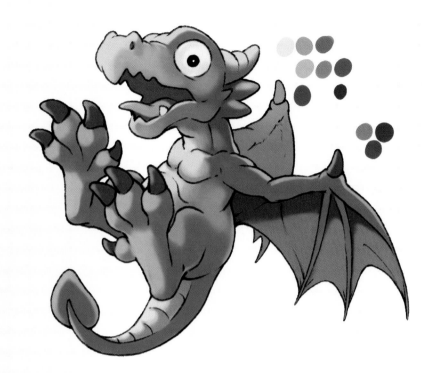

9 Pick Colors

Wyverns occur in a range of colors, but darker tones like black, blue, purple and gray are most common, beneficial for a stealthy night hunter. This whelp's purple-blue scales and golden underbelly will darken with age. Once you've selected your colors, build up the basic shadow tones to indicate a light source coming from the wyvern's right side.

10 Finish With Shading

Continue building up the shadow tones with darker shades of purple. Fade the far wing with a light gray tone. Paint a hard yellow edge (perhaps the glow of moonlight) along the claws and right side of the wyvern's body. Finally, apply a scaly texture by dabbing rows of circles with a lighter tone. You can break up the monotony of the pattern by highlighting select scales. Now, step back and watch your wyvern take flight!

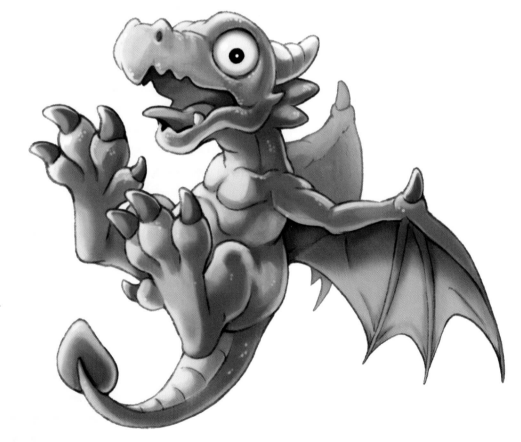

Phoenix Chick

Rising from the ashes to be reborn again and again, the phoenix is an immortal bird of great power and benevolence—a symbol of the cyclical dance of death and birth seen through nature. It also appears as a messenger of hope, peace and prosperity to those lucky enough to see it. Sometimes called the firebird, its dazzling red and orange plumage is protected by a veil of continuous flame. The phoenix stands 4 feet (1m) tall, with a tremendous 20-foot (6m) wingspan, making it a bird of legendary size.

Despite its grand presence, the phoenix is notoriously illusive. It spends the majority of its 500-year life cycle cloistered in carefully selected venues, hidden from the many creatures who seek its audience in the vain hope that its feathers or blood will grant it immortally. When it approaches the end of its current incarnation, the phoenix builds a nest of wood and incense for its pyre, and allows itself to be consumed by the flames. There is only one phoenix in existence at any given time—a baby phoenix is born from the ashes of the adult, and shares its ancestors' knowledge and memories. In this way, the phoenix lives forever.

Plan the Design

Sketch poses for your phoenix chick, with a demeanor ranging from simmering aggression to full-blown fiery anger. The phoenix is sometimes described as looking like a blend between an eagle and a peacock, so look to their offspring for pose inspiration and proportions.

PHOENIX STATS

SPEED:	4
STRENGTH:	2
MAGIC:	5
CUNNING:	4
SPECIAL ABILITY:	ETERNAL FLAME

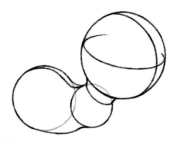

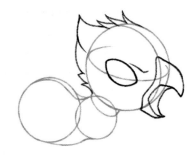

2 Draw the Body

Sketch a circle for the head. Add guidelines to indicate the direction of its gaze. Beneath that, draw a smaller circle for the chest. Connect them with a short tube-shaped neck. Then draw a medium circle at the rear. Extend a line along the belly, and another line along the top to complete the body shape. Sketch a center line along its back (following the spine).

3 Build Up the Head

Sketch an angular, almond-shaped eye with lowered brow along the horizontal guideline. Draw the sharp-tipped beak along the vertical guide, stretching from forehead to base of the head. Flare out the top of the head with jagged plumage.

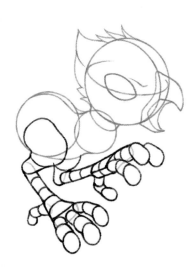

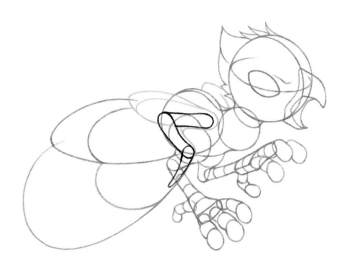

4 Draw the Legs

Because the phoenix is taking flight, the legs can grasp and claw freely. Sketch the rounded thigh area connecting to the body at the hip. Then draw the upper and lower leg portions using long tube shapes. Add surface lines. Cap the end with a rounded box for the foot. Add a curving toe to the back of the foot and three more in the front. Divide each toe into three segments.

5 Sketch the Wings

Draw the bones of the wing using simple tube shapes. Sketch the wing shape in three sections: primaries, from the wing tip to wrist joint (denoted in pink); secondaries, from the wrist to the elbow joint (purple); and tertiaries, from the elbow joint to the shoulder (green). Subdivide each section to create an overlapping layer of covert feathers. Don't forget the far wing.

6 Draw the Face and Fluff

Draw the eye with a double-ringed pupil, lavishly thick lashes and a furrowed brow to create a fiery look. Sketch a ring of plumage around the neck and legs. Fluff up the rump with some blazing tail feathers. On the beak, add a V-shaped nostril and a pointy tongue.

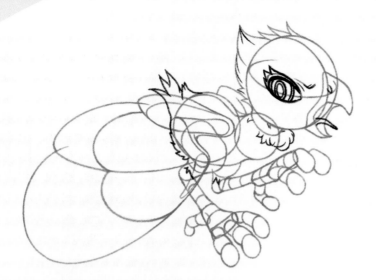

7 Detail the Feet and Tail

Sketch rigid plating with rounded edges, called scutes, down the length of the phoenix's feet. Cap the end of each toe with a sharp talon. Sketch a pair of long decorative feathers erupting from the tail end and twisting around each other.

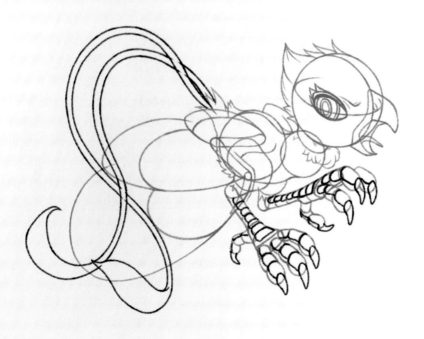

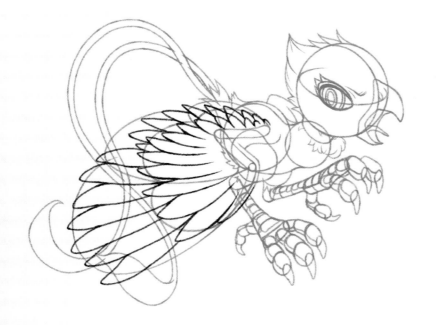

8 Draw the Feathers

Starting from tertiaries, moving onto the secondaries and primaries, draw each feather overlapping the next. Then draw the upper layers of covert feathers, following the same overlapping pattern. Keep in mind how each feather connects with a specific section of the wing arm, and angle them accordingly.

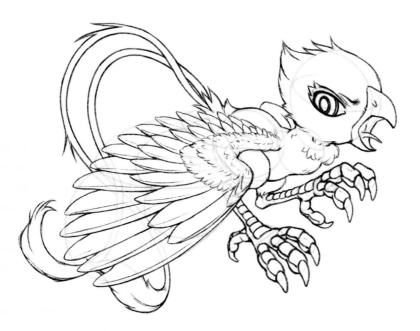

9 Refine Lines

Carefully go over your lines, darkening around creases. Add texture details to the top layer of covert feathers, and draw the alula, a bird's "thumb" feathers. Fluff out the tail tips. Lightly pencil a line indicating the inner shaft of each major feather. Erase the body lines beneath the wings and the rest of your guidelines.

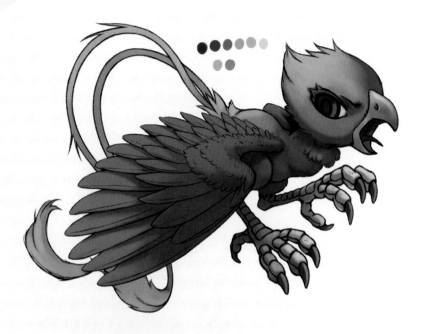

10 Pick Colors

Select colors for your baby phoenix that evoke the feeling of fire: reds, oranges and yellows. Gradually blend these tones across the body, creating smooth gradations. I used a subdued purple on the twin tails to help separate and set them back from the wing. Add some shadow tones to the undersides of forms.

11 Finish With Shading

Continue to build up the shading, playing dark against light on hard, glossy surfaces such as the claws and beak. Add highlights along the feather tips. Follow the barbs pulling from the feather shaft with brisk strokes. Shine up the eye with a circular dab of white.

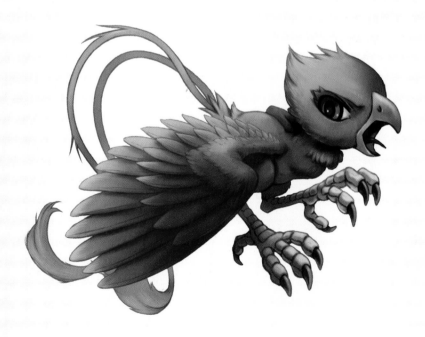

12 Set It On Fire

Finally, it's time to turn up the heat! Paint the basic shape of the flames with an orange tone. Then build up the interior with a lighter yellow. Using a brush with a sharp edge, add small circular flecks of fire casting off the main flames. Smudge and smear the fire colors together to blur them, making the flames dance with flickering life.

A Final Word of Advice

It is our sincere hope that this book helps to inspire you and provide you with a foundation to create your own little fantasy creatures.

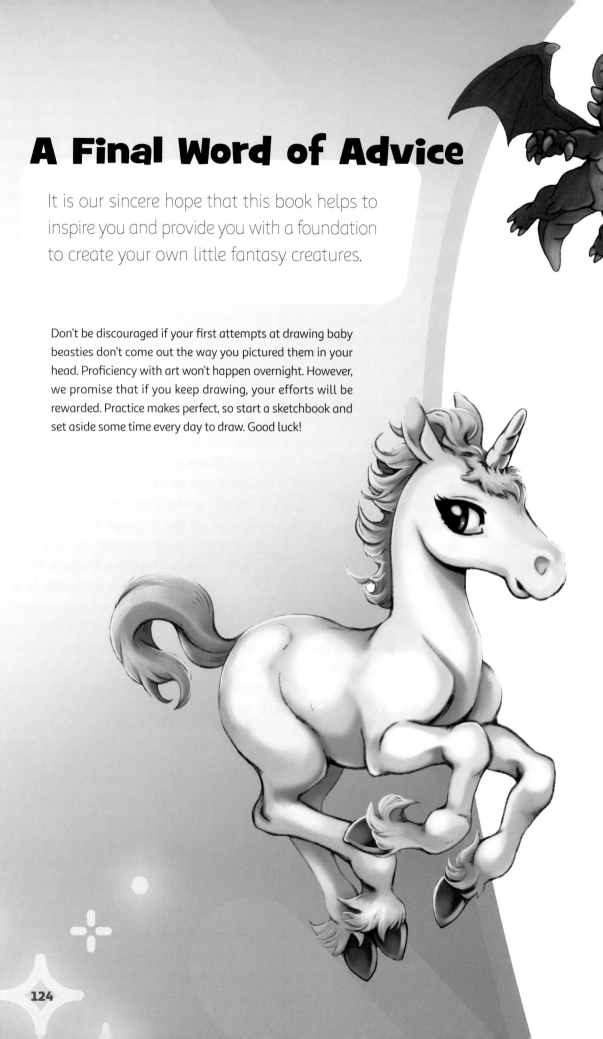

Don't be discouraged if your first attempts at drawing baby beasties don't come out the way you pictured them in your head. Proficiency with art won't happen overnight. However, we promise that if you keep drawing, your efforts will be rewarded. Practice makes perfect, so start a sketchbook and set aside some time every day to draw. Good luck!

Index

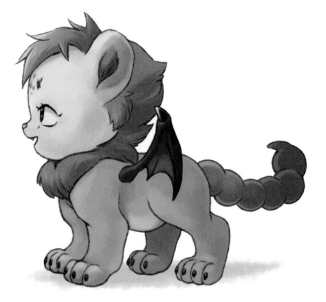

About
The
Authors

Lindsay Cibos and Jared Hodges specialize in illustrations and sequential art. Lindsay drew the baby beasties featured throughout this book, and Jared co-wrote the book, adding artistic insights and quips. Lindsay and Jared are the creators of the graphic novel trilogy, *Peach Fuzz*, and the webcomic *The Last of the Polar Bears* (lastpolarbears.com). They have also co-authored several art tutorial books, including the *Draw Furries* series (recipient of the 2009 Ursa Major Award for Best Anthropomorphic Other Literary Work) and the *Little Pony Drawing Book*. They're lifelong residents of sunny central Florida, where they spend the majority of each day hiding from the light in their studio while making art. Visit them on the web at jaredandlindsay.com.

Other fine IMPACT Books are available from your favorite bookstore, art supply store or online supplier. Visit our website at fwmedia.com.

a content + ecommerce company

23 22 21 20 19 5 4 3 2 1

DISTRIBUTED IN THE U.K. AND EUROPE
BY F&W MEDIA INTERNATIONAL LTD
Pynes Hill Court, Pynes Hill, Rydon Lane, Exeter, EX2 5AZ,
United Kingdom
Tel: (+44) 1392 79680
Email: enquiries@fwmedia.com

ISBN 13: 978-1-4403-5419-9

Edited by Mary Burzlaff Bostic
Cover designed by Clare Finney
Interior designed by Brianna Scharstein
Production managed by Debbie Thomas

METRIC CONVERSION CHART

TO CONVERT	TO	MULTIPLY BY
Inches	Centimeters	2.54
Centimeters	Inches	0.4
Feet	Centimeters	30.5
Centimeters	Feet	0.03
Yards	Meters	0.9
Meters	Yards	1.1

Acknowledgments

Thanks as always to our family and friends for their love and support. Thanks also to everyone at F+W Media, especially our editor Mary Bostic for her help and guidance, and Clare Finney with her keen eye for design. And of course, a very special thanks to you, dear reader, for picking up this book!

Dedication

To our little dragon, Drake.

Ideas. Instruction. Inspiration.